SECRET ABERGAVENNY

By Tim Butters

AMBERLEY

First published 2017

Amberley Publishing
The Hill, Stroud
Gloucestershire, GL5 4EP

www.amberley-books.com

Copyright © By Tim Butters, 2017

The right of By Tim Butters to be identified as the
Author of this work has been asserted in accordance
with the Copyrights, Designs and Patents Act 1988.

ISBN 978 1 4456 6688 4 (print)
ISBN 978 1 4456 6689 1 (ebook)

British Library Cataloguing in Publication Data.
A catalogue record for this book is available from the
British Library.

Origination by Amberley Publishing.
Printed in Great Britain.

Contents

Acknowledgements

A big thank you to Udo Schultz, Charles Trott, Malcolm Lewis, Michael Woodward, Andy Sherwill, David Bowen, the *Abergavenny Chronicle*, and everyone else whose superb images have helped make this book a lot more colourful than it otherwise would be.

Introduction

History is a strange old thing. There's more of it with each passing second to record, file, and interpret. Yet it's always the living history that escapes the general categorisation of the sterile specimen jars, and ends up seeping through the cracks of the establishment to form sometimes unsightly, sometimes memorising puddles of liquid mercury on the cutting room floor, which reveals more about the character of a place than a dreary parade of cold, hard, impartial and objective facts ever could.

Despite what they teach you in school, history has never just been about the facts. It's also about interpretation, perspective, and the heart that observes it, carries it, and retells it with each subsequent beat.

In a nutshell, *Secret Abergavenny* is a book that firmly believes in Rudyard Kipling's old adage that the past would be a lot more memorable, entertaining and colourful if it could be told through the medium of good stories.

Consequently, this book does exactly what it says on the tin. If you want the shop window's history of Abergavenny, you've come to the wrong show, but if you want to scratch the surface and dive head first into the sometimes inspiring, sometimes sordid realities that lie just beneath the official veneer, then we've got just the ticket for you. So step right this way.

If you want to learn about the history of a town, talk to its inhabitants, and if you want to learn its secrets, keep talking. With this in mind I have strived, where possible, to give a uniquely human and personal angle to many of the tales in this book, from the people who were actually a part of history in the making. On that note I'd like to thank each and every one of them for taking the time to share their stories with me.

And to all you 'official' historians out there, I'm a newspaperman by trade and *Secret Abergavenny* doesn't claim to be a comprehensive history of Abergavenny. It isn't even a detached and impartial observation of the facts.

I'm not sure about you but that kind of history leaves me colder than a dug-up corpse. I'm a firm believer that if you want to make the past as dull as ditch water, then regurgitate the official line time after time to ad nauseam.

But (and it's a big but) if you want to bring the past to life and close the gap between the decades and centuries until you can see the whites of the protagonist's eyes, then you've got to fire it up with some juice, and plenty of it.

I suppose the ambition of this book, if it has one other than to entertain, is to introduce Abergavenny in a new light. A neon, eye-catching and slightly garish light, that says, 'Look at me! There's a lot more to me than you've ever realised folks'.

So there we have it. The stage is set, the lights are dimmed, the curtains go up, now gather around and watch old mother Aber sing an unfamiliar and slightly off-key song as she waltzes through the centuries with her skirts pulled high, fuelled solely by a robust determination to never let the facts get in the way of a good story. Enjoy!

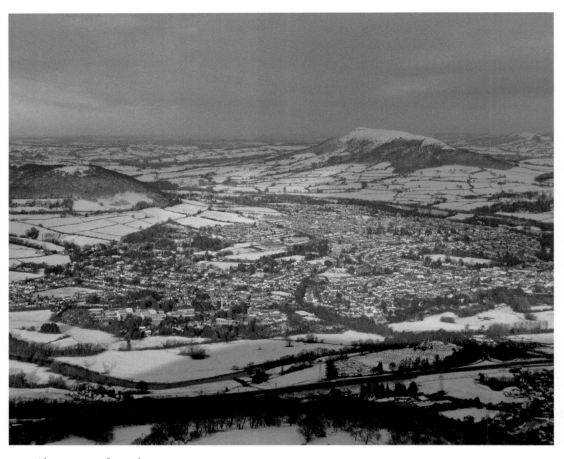

Abergavenny from above.

1. It Begins with a Slaughter

A Beginner's Guide to Abergavenny

Just like Rome, Abergavenny is surrounded by seven hills, and although any similarity between the 'Eternal City' and the 'Gateway to Wales' may end there, there's a lot more to this sleepy market town than meets the eye.

Although neither a cathedral city nor the county town, Abergavenny has always punched above its weight because of its strategic position as the 'Gate of Wales'.

Like all gripping yarns, the story of Abergavenny begins with a bloody slaughter. Hard-core historians may beg to differ, but ask most inhabitants of the town about an event from the area's ancient history and they'll regale you with the tale of how one Christmas Day in 1175, the lord of the manor, William de Braose, fondly remembered as the Abergavenny Ogre, kindly invited all the local Welsh chieftains to a festive knees-up at the town's castle.

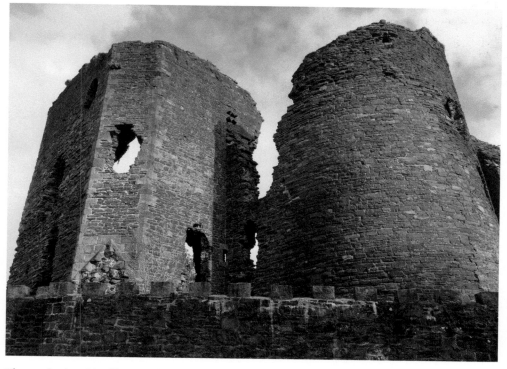

The castle that Sitsyllt ap Dyfnawl and his men journeyed to and where they were unwittingly slaughtered.

Willing to put aside years of bloody conflict, the Celts happily accepted the Norman lord's invite and, led by Sitsyllt ap Dyfnawl, the Welsh lads turned up expecting to share a few gallons of ale and make merry with the boys from France. Except the only thing on the menu that night was carnage, and lots of it.

After politely leaving their swords, axes, and spears at the door, Sitsyllt and his crew took their seats at the table in the Great Hall, picked up their goblets of mead and looked forward to the hog's head, roast swan, and other Norman delicacies on offer. But things turned sour quickly when Lord William announced he had recently decided that from that day on no Welshman should have the right to bear arms, so there.

As you can imagine, this little revelatory nugget sat in the stomach of the gathered assembled about as well as an undercooked chunk of rotten fish, but before they could protest, or beat the living daylights out of Willy for his brass-necked audacity and poor etiquette, it all went to hell in a handcart.

At a curt prearranged nod of the head from William de Braose, the time-honoured bond between visitor and guest wasn't so much broken but ruthlessly torn apart, as a horde of soldiers led by the Sheriff of Hereford, Ranulph Poer, descended upon the unarmed and shell-shocked Welshman and butchered every last one of them in gleeful savagery. All except Prince Iorwerth of Caerleon, who is said to have a wrested a sword from a witless Norman and hacked his way through the throng to liberty and life.

Not content with such a massacre, the bloodthirsty butcher Braose saddled up a posse of his men the very next day and once again went on the rampage. This time to Sitsyllt's home where, in front of his widow, they killed his seven-year-old son Cadwaladr.

The castle as seen from Castle Meadows in the swinging '60s.

Such treachery and psychopathic behaviour earned de Braose a defining role in Abergavenny's history. The belligerent brute nearly got his just rewards in 1182 when the sons of the slaughtered Welshmen came of age and stormed the gates of Abergavenny Castle, killing the entire garrison, but to their disappointment, de Braose and his wife Maud were elsewhere.

Wicked Willy continued to narrowly escape justice for his diabolical deeds, and he was never dealt retribution by a Welsh hand. Instead he fell out of favour with King John and, after having all his castles seized, he fled to Ireland with his family, where his wife and eldest son were captured by the king's men and starved to death at Windsor Castle, such were the niceties of Norman nobility.

As for the Abergavenny Ogre, he fled to France disguised as a leper, where he died on 9 August 1211. An ignoble end to a wretched creature.

DID YOU KNOW?

In 1905 Abergavenny had reason to celebrate: the town had a Dick Whittington all of its own when local lad Walter Morgan became Mayor of London. The Morgan family used to reside at the town's Angel Hotel and, in 1846, at the age of fifteen, Walter set off for the big smoke seeking fame and fortune. He got it. After becoming mayor, he went on to receive a knighthood. Not bad work for someone who left school before they were sixteen.

Roam and Find a Home

Of course things happened before the slaughter but they're not really that secret or entertaining. The Romans, of course, liked to roam, and a long time ago they found themselves in this particular patch of Wales, built a fort and called it Gobium, as they busied themselves in subjugating the Silures, who were the tribe of Celts that used to rule the roost in this neck of the woods.

The Romans were here for a while and then cleared off. They did leave a few things behind though, one of the most interesting being the Leopard Cup. The Abergavenny antique was discovered by Gary Mapps while metal-detecting near Abergavenny in 2003. Thought to have been made in Italy during the first century AD, the cup is similar to other vessels that were found at the city of Pompeii. Its decorative handle, carved into the shape of a leopard with silver spots, gives the cup its name.

In Roman mythology, the companion of Bacchus (the god of wine) is a leopard and such a finely made cup probably belonged to a person of high status, or possibly an alcoholic, who desired it to be buried with him.

Described as one of the finest vessels ever found in Wales, it currently resides in Cardiff's National Museum and is not even used at Christmas.

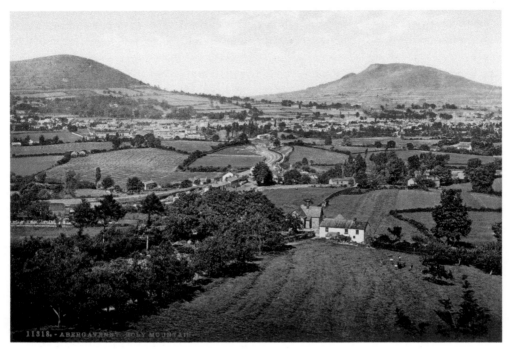

Abergavenny's 'Holy Mountain' featured on a postcard from 1890.

Noah and his Ark Swing Our Way

Long before the sword and sandal brigade swung our way, Brother Noah of Old Testament fame was also thought to have made a brief detour through Abergavenny in his legendary ark. The story goes that the Skirrid Fawr Mountain, also known as 'the holy mountain', got its distinctive appearance when it was underwater during the time of the great flood and Noah's Ark cut through the middle of it, bestowing upon it a strange cleft-like appearance.

Scientists, of course, will suggest that the strange fissure dividing the mountain was caused by a disruption during the volcanic period, but local legend hints that if Noah wasn't responsible, maybe Satan was.

The story goes that the horned one was idly flexing his muscles one day and testing his strength by throwing stones off the top of the mountain. Apparently one landed in Trellech, the other in Tintern, but just as old Lucifer was about to heave the final stone, his foot slipped and formed a deep hollow in the mountain, where in later years an old chapel of St Michael was erected, all traces of which have since disappeared.

The Welsh Westminster

Abergavenny boasts its fair share of holy houses. Most notable is St Mary's Priory. Built in around 1070 and often referred to as Wales's very own Westminster Abbey, the Norman building lies on top of a religious site dating back to Celtic times.

St Mary's nearly became a cathedral for the diocese of Monmouth in 1910 but just missed out by a few inches, as Newport Cathedral won the day. Nevertheless, St Mary's

is a treasure trove of religious relics. It boasts more than ten alabaster chest tombs and a fifteenth-century wooden sculpture known as a Jesse Tree. When this large chunk of oak was on display at London's Tate Britain during the turn of the century, it was described as 'one of the finest medieval sculptures in the world'.

In St Mary's Churchyard there is a peculiar looking stone that is definitely not a tombstone but a stone that bulls were tied to in the days when bull-baiting was all the rage in Abergavenny. The town has long been noted for its breed of bulldogs, which had a reputation of getting hold of a bull's nose and refusing to relinquish their hold until the agonised beast succumbed and rolled over on its back.

People were said to immensely enjoy such 'sport', which according to an old report in the *Abergavenny Chronicle* also had the added bonus of 'rendering the meat of the cattle about to be slaughtered tender and wholesome'.

DID YOU KNOW?

Eagle-eyed observers will notice that the north face of Abergavenny's town clock is painted black. It was done to commemorate the death of Prince Albert, who passed away in 1861, and thus it remains to presumably remind the town folk of the nature of morality and the illusory nature of time. Or perhaps not.

The 'Welsh Westminster' in all its stately splendour.

St Abergavenny

Not many towns can boast their very own saint but Abergavenny can. David Lewis, also known as Charles Baker, was born in Abergavenny in 1616, and in 1970 was among forty English and Welsh martyrs executed for their religious beliefs who were canonised by Pope Paul.

Although David was well liked by both Catholics and Protestants, he was nevertheless a Catholic and a Jesuit to boot, which in an era where the government actively persecuted people for their religious persuasion was very dangerous. Father Lewis was ordained in Rome and later held religious ceremonies in a secret attic chapel in Cross Street's Gunter House and was rumoured to have led pilgrimages up the 'holy mountain' to the old chapel of St Michael.

He was arrested at Llantarnam in 1678 and appeared before the Monmouth assizes on 28 March 1679, who condemned him to die a traitor's death in accordance with the Protestant law of the time. He was later offered his freedom by a privy council in London in return for the low-down on the 'Popish Plot' and his willingness to conform to the Protestant Church, but he remained firm in his resolve and was determined to die as a Catholic priest.

On 27 August 1679 Father Lewis was hanged and disembowelled in Usk's Porthycarne Street. His body was burnt and the remains are buried outside the west door of Usk's St Mary's Priory Church.

Before he met his grisly end, Father Lewis addressed the crowd in Welsh and said, 'I was condemned for reading Mass, hearing confessions, anointing sick, christening, preaching, and worshipping God. For religion I die.'

The notorious 'Traitor's Lane' where Glyndwr gained entry into Abergavenny.

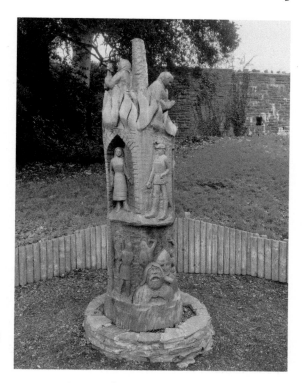

A sculpture in Linda Vista Gardens showing the Christmas Day massacre, Glyndwr entering the town, and St David Lewis being punished for holding secret Catholic services in Abergavenny.

Abergavenny Under Attack

Although Abergavenny kept her head up and managed to survive the horrors of the Black Death in the 1340s, a short time later in 1404 the last true Prince of Wales, Owain Glyndwr, burnt, looted and pretty much plucked the old mother duck senseless during his prolonged revolt against the English.

Glyndwr was said to have been granted access to the then walled town through a gate in Market Street by a sympathetic lady who perhaps didn't realise the prince and his posse harboured plans to burn Abergavenny to the ground. Henceforth, Market Street is often known as Traitor's Lane.

One of Glyndwr's many illegitimate sons, known as Ieuan ab Owain Glyndwr, later declared Abergavenny its own nation, but it wasn't practical and failed to catch on with the locals; the whole misguided social experiment is believed to have only lasted a fortnight.

The French Connection

As a young soldier storming the beaches of Normandy, Abergavenny's Second World War veteran David Edwards never imagined he would return sixty-five years later to the shores where the fate of the world was decided and find himself speaking to the French prime minister's wife. And never in a month of Sundays would Mr Edwards have once imagined that the first British woman to be married to a French premier would also hail from his hometown.

Abergavenny's name comes from the River Gavenny, which runs through the town and is pictured here merging with the mighty Usk.

It sounds stranger than fiction, but that's exactly what happened when Mr Edwards spent a few rare moments chatting to Penelope Fillon at the 65th D-Day anniversary memorial service held at Bayeux Cemetery. 'It came about by a complete accident,' revealed Mr Edwards. 'I was standing with a group of cadets and veterans on one side of the walkway that Prince Charles and various other dignitaries were passing through, when I noticed a very lovely lady carrying a small Welsh flag. She came very close to where I was standing, so I said 'Abergavenny' like it was some sort of code word, and immediately her head shot around in my direction and she came over.'

After asking Mr Edwards where he was from and discovering that they were both 'Abergavennyites', the two of them soon started fondly reminiscing about the Gateway to Wales.

'She was a lovely lady, with no airs or graces about her, and seemed to fit into the situation perfectly,' revealed Mr Edwards. 'I was very impressed by her manner and the way she conducted herself, and I thought what a fine ambassador for Abergavenny to have.'

This was not the first time Mr Edwards has revisited Normandy. Mr Edwards has the rare honour of having a school in the Normandy town of Mondraiville part-named in his honour. L'École Edwards Griffiths was so-called after the Mayor of Mondraiville and a teacher at the school suggested naming it after the Abergavenny war veterans to remind pupils of the war and the bravery of those who fought in it.

As for Penelope Fillon, she very soon could become France's First Lady and move into the Élysée Palace if her husband Francois Fillon defeats Marine Le Pen in the French election.

The Only Thing Changing is Change

Believe it or not, Abergavenny was once famous for its wigs. The townsfolk possessed a secret method of bleaching that produced whiter-than-white wigs, which were the envy of lords and ladies from all over Albion and beyond.

Yet every fashion item has its day, and when wigs went the way of flares and platform shoes, Abergavenny became renowned as a health spa town where people came to bathe in goat's milk, believing it to be a better cure for tuberculosis than the bitter waters of Bath.

In 2012 over 150 years of Abergavenny history came to an abrupt end when the town's famous cattle market held its last livestock sale. The once-famous cattle market has since been reduced to rubble by heavy machinery and, with supermarket giant Morrisons waiting in the wings and eager to make an appearance, a small corner of the town is still very much in a transitional period or, in other words, a complete mess.

The past may be buried under debris and the future may remain a picture yet to be painted by artful architects, but the present, as always, is right in your face. Which brings us bang up to date. Like many towns in the modern age, Abergavenny is reliant in part on tourism and has proved herself particularly adept at holding hugely popular annual events. The town's festival of cycling and the steam rally are unique dates in the town's calendar, but it is probably the Abergavenny Food Festival that has really put the town on the map in the twenty-first century.

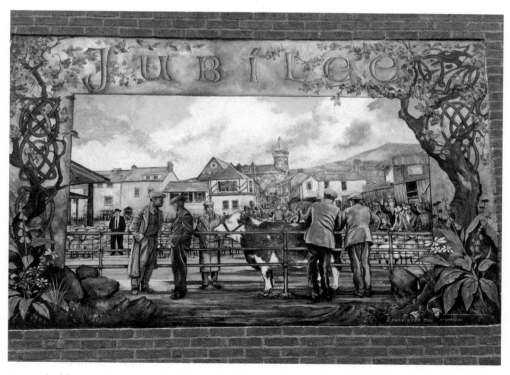

A mural of farmers inspecting the livestock at the town's once-famous cattle market.

An integral part of Abergavenny's past now lies as rubble.

Every September culinary connoisseurs come forth, gastronauts descend, food specialist's swarm and the swine are roasted over a spit, packed into extortionately priced burgers and forced upon the palettes of the herds of people that flock to Abergavenny's annual hog heaven.

With its beginnings in 1999, the Abergavenny Food Festival has progressed from a low-key localised event to a highlight in Britain's culinary calendar, and one that is now widely considered to be the best festival of its kind in Britain.

DID YOU KNOW?

The wreck of Abergavenny isn't the nickname of a local drunken ne'er-do-well who used to haunt the town, but the name given to the tragic *Earl of Abergavenny*, a ship that was part of a convoy heading for China when it sank off the coast of Portland on 5 February 1805. The tragic loss of 260 lives included Captain John Wordsworth, brother of the famous poet William.

The Eisteddfod Returns

Talking of festivals, it's only right that we end this scattered history of Abergavenny with a mention of the 2016 National Eisteddfod of Wales held on the town's Castle Meadows. In August of that year the small town with a population of roughly 14,000 became the capital of Wales for a week. Abergavenny first held the National Eisteddfod in 1913, and the Gorsedd Stones from the event can still be seen standing proud in the town's Swan Meadows.

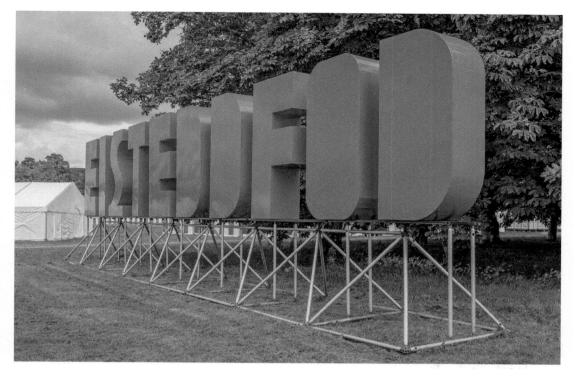

In 2016 the Eisteddfod returned to the predominantly English-speaking Abergavenny and was hailed an overwhelming success.

They don't use real stone circles at the Eisteddfod anymore, it's too inconvenient, but the Eisteddfod still believes fiercely in the bards, the druids, the ceremonies, and the celebration of Welsh culture. The event attracted visitors from far and wide to the Gateway to Wales, with an estimated 25,000 people passing through the gates each and every day.

What the Ogre of Abergavenny would have made of all those predominantly Welsh-speaking visitors on the Maes is anyone's guess. Indeed, even as recently as 1959 people in Abergavenny were being arrested for speaking Welsh, albeit inadvertently.

An *Abergavenny Chronicle* report from that year reads, 'A soldier accused of using obscene language in Aber's main street revealed in court he had been merely speaking Welsh. "The policeman thought we were swearing, but we were speaking in Welsh. We spoke in Welsh and that seemed to annoy the police sergeant. This is not the first time they have picked on us for speaking Welsh," he said.'

No doubt if a Welsh prince by the name of Owain Glyndwr took a stroll around Abergavenny during Eisteddfod week he would have been more than impressed to see his battle standard flying gently on the breeze in a town he torched to the ground some 600 years earlier. Abergavenny may not be its own nation anymore but, in terms of history, it remains in a league of its own, as hopefully you're about to find out.

So without further ado, let's jump into our magic time machine and travel back through the ages to Victorian Abergavenny for a gruesome tale of murder most foul.

2. Bloody Mary

Four years after the blood and butchery of the Jack the Ripper killings left a permanent stain on the streets and slums of London's old East End, Abergavenny was rocked to the core by its very own torrid and twisted tale of savage murder and prostitution.

Let's now lift the lid off a little-known tale in the town's history that plays itself out like a penny dreadful saga full of the hellish horrors of wanton bloodlust, twisted retribution, loose virtue, unmarked graves and finally the inexorable and mocking swing of the hangman's noose.

It was another busy Friday night in Victorian Abergavenny, the date was 16 September 1892, and the public houses were heaving with the trade of customers eager for the high spirits and blessed oblivion to be found in a pint of beer or shot of whiskey. Yet for one reveller this bawdy night of drunken abandon was to be her last.

Mary Conolly, a well-known alcoholic and prostitute, was celebrating her release from Usk gaol after spending the last twenty-eight days there for being drunk and disorderly.

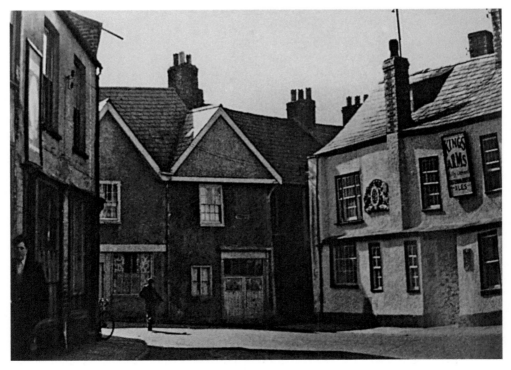

A picture of just how different Abergavenny's St John's Square used to look.

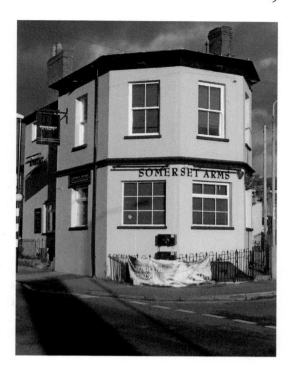

The pub where Mary took her last drink on this mortal realm.

Mary was renowned throughout town as a 'slave to the bottle' and during the day she had stumbled from one public house to the other, busily slaking the thirst of the demon on her shoulder while toasting her newly acquired liberty.

In her rounds of long-forgotten Abergavenny pubs, such as the Foresters Arms, the Cross Keys, and the Old Duke Inn, she was accompanied by a strange man not familiar to the beady and enquiring eyes of the local inhabitants. Her final port of call and last shot of liqueur before she was ripped bloodied and screaming from this mortal coil was in the snug confines of the town's Somerset Arms.

At 7.30 p.m. that evening Mary and her companion entered the pub, where she ordered a whiskey for herself and a beer for the mysterious man. Less than an hour later Mary's throat was cut from ear to ear with such animalistic savagery that her head was almost decapitated. Covered in blood and in what must have been unbearable agony, she dragged herself 200 yards from the spot where her attacker had left her for dead in a desperate bid for help before the life seeped out of her completely. Unfortunately her wounds were far too severe and Mary, lying prostrate and pale in a pool of her own blood, was found in the gutter only a short time later by railwayman Edward Wilkins.

The poor doomed daughter of Jeremiah Conolly and resident of Pant Lane would never again bear witness to the rising of a sun or the falling of a star. Her eyes were unseeing, her heart had been stilled and her final horrors had been rendered mute for all time. She was tragically dead, butchered by the murderous whim of a madman's hand at the age of twenty-two.

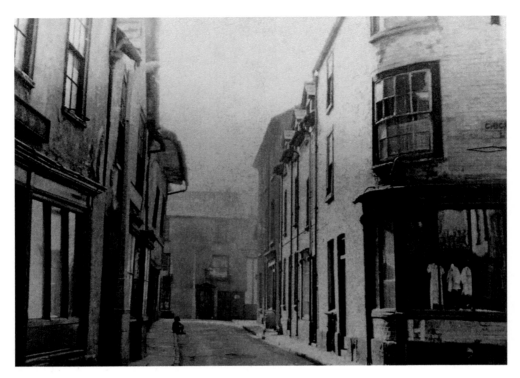

An atmospheric shot of old Abergavenny.

An *Abergavenny Chronicle* report from 23 September 1892 states, 'The scene of the murder was on one of the allotments abutting upon the newly made Hatherleigh Road and leading from Brecon Road near Hatherleigh Lodge to the Union Lane a few yards below the workhouse garden.' The report goes on to read, 'A guard employed by the railway company was proceeding to work along Hatherleigh Road when his attention was attracted by smothered choking sounds and having struck a match he looked around and discovered what he first thought to be a heap of clothes in the gutter. On closer examination he found it to be a woman with her face covered in blood and her dress saturated in blood, which had flowed from a deep gash in her throat.'

Wilkins ran off to inform the police immediately and word soon spread like wildfire through what was then known as the Irish part of town, where Mary had lived. The 'Irish part' of town, so-called because of the number of Irish immigrants residing there once encompassed the whole of the Tudor and Castle Street areas with its characteristic sprawl of medieval and Elizabethan dwellings, narrow, winding streets, numerous pubs and well-known brothels. This was of course prior to the slum clearance schemes of the 1950s and '60s, which many felt ripped a lot of the heart and soul out of 'old mother Aber'.

The murder scene was visited by the county police surgeon Dr Elmes Steele before Mary's corpse was removed to the workhouse mortuary, where Steele ascertained the cause of death as a massive wound that had severed the windpipe. Superintendent Freeman, who also attended the scene of death, said at the inquest, 'I saw her [Mary] in the

position in which she was found. She was on her back, face upwards, she was in the gutter lengthwise, her head towards Brecon Road and her feet toward the Union.' The *Chronicle* reported, 'A minute description of the man who was seen in the girl's company was given and great anxiety was manifested throughout the town that the culprit should not escape.'

The town needn't have worried because, to everyone's shock, a little over a day later a thirty-year-old man living in Lower Hill Street, Blaenavon, who went by the name of Thomas Edwards, walked into the police station in the early hours of Sunday morning and confessed to Mary's murder. Edwards, a former soldier who had previously served in the 53rd Shropshire Regiment, was said to exhibit little concern regarding his position and showed no remorse or regret. He was described as a man of slight build with a somewhat vacant expression.

In a voice devoid of all emotion Edwards told the court during his one-day-trial, 'She [Mary] asked me to go along with her and she took me into some garden or field. She laid down and I cut her throat with a razor. I knew her before about two months ago and she took my two pound off me and she had also given me the "bad disorder".' Quite shockingly, a cold-blooded Edwards went on to reveal, 'I left her on the ground and came back to the same public house [Somerset Arms] at which I had a glass of beer.'

Edwards's Blaenavon landlady Mrs Morgan later explained to a reporter from the *Western Mail* that Edwards would often go to Abergavenny by train for the purpose, so he made out, of seeing a sister. On one occasion he stayed four or five days and returned without any money, suggesting that Edwards had more of a relationship with Mary, or at least other women of 'ill repute', than he later cared to admit.

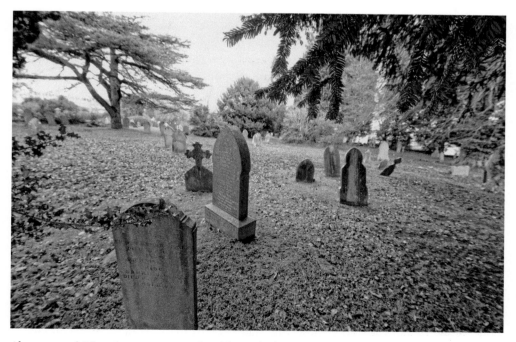

Abergavenny's Victorian cemetery on the Old Hereford Road where Mary could have been laid to rest.

DID YOU KNOW?

Near a stone bridge in the Mill Street area over 200 years ago was a stile and what was called the 'ducking pool', in which wives who had strayed, women of 'loose virtue', and other females who had incurred the wrath of the townsfolk were dunked. The unfortunate women were paraded around town in a cart and, upon their arrival at the pool, those about to be immersed were hooted and jeered by assorted Abergavenny folk, before being dragged screaming and struggling from the cart and thrown into the pool.

Edwards's defence pleaded that the accused was of not sound mind and that his mother had been confined to Abergavenny's Pen-y-Fal Asylum for the last twenty years. It was further revealed that his uncle was known as a complete imbecile and his grandfather went by the name of 'silly Davis'.

In his only explanation of why he took such a young life and cruelly cut it short, Edwards said, 'I think it is about six or seven years since Colonel Findall commanding the Shropshire Regiment was murdered in Birmingham by one of these loose girls. Since then my mind has always been against them. If I had a good chance I should have killed one before, and intended going to Newport and killing one or two there, only I had no money. I served in the Egyptian campaign and got invalided from there with a very bad fever and suffered from pains in my head and I had suffered from the pains before committing the deed.'

The jury didn't hesitate in passing a verdict of guilty and in passing sentence. The judge told Edwards, 'I can only pray you take earnest advantage of the time you have yet to spare here. Short as it may be, it is abundantly sufficient to prepare yourself for the meeting of your God.'

Said to be apparently unconcerned to his impending fate by all those who visited him in Usk Prison, Edwards kept his appointment with the hangman's noose at 8 a.m. on 27 December 1892. Minutes later a black flag with the word 'JUSTICE' emblazoned upon it in bold white capitals was hoisted high above the prison walls. The assembled crowd greeted the sight of the flag with cheers as it flew fiercely indifferent and eternally elusive in the grey early morning skies.

Yet for poor Mary even death could not free her from further indignity. As a Roman Catholic, the church to which she belonged deemed her as a 'notorious public sinner' and refused her the usual Catholic rights of burial on the grounds that she had not been reconciled with her maker before death.

As such there was no burial service for Mary, who was finally laid to rest in an unmarked common grave as a handful of her relatives and friends offered up silent prayers to a distant and authoritarian God in the hope of some sort of salvation for the girl they had once known and loved.

A curious blend of the old and the new in modern Abergavenny.

How the approach to Tudor Street would have once looked.

DID YOU KNOW?

At the end of Mill Street there used to be a notorious alley that followed the Gavenny River and led to Castle Meadows. The alley was said to a popular haunt of highwaymen in the late eighteenth century. As the punishment for highway robbery was the same as for murder, victims were often killed in case they later identified their assailants.

The Great Slum Clearance

Just as it's impossible to read about the Jack the Ripper murders without conjuring up in the mind's eye the shadows and slums of Whitechapel, it is impossible to read about the tale of poor Mary Conolly without thinking of how different the Abergavenny she lived and died in would be to the modern eye before the civic planners systematically destroyed much of the old part of the town during the wholesale slum clearances, which were given the green light in 1957.

In gung-ho fashion, many fine Elizabethan buildings and, more importantly, people's homes were bulldozed to make way for the sharp-edged utilitarianism and banal-box designs of modernity. Many fine Elizabethan buildings and public houses in Tudor Street and St John's Square were replaced with a police station, magistrates' court, job centre, and post office. Suffice to say, the unique character of the area had been somewhat diminished, and the community had been broken, scattered, and moved on to purpose-built council homes elsewhere.

Addressing the Abergavenny Borough Council at the time, Alderman V. R. Pugsley reflected on the demolition of Tudor Street, Byfield Lane, St John's Square, Mill Street, and parts of Flannel Street, Chicken Street, and Nevill Street with the following nugget of town planning wisdom: 'It should be remembered that what we do will affect this town for many years to come.' And indeed it did.

Ironically, until the middle of the nineteenth century Tudor Street was where rich merchants and respectable town burgesses lived the life of riley in enormous houses. Its reputation as Abergavenny's wealthiest suburb took a hit toward the latter half of the nineteenth century. The grand houses were split into tenements and in their former gardens and coach yards small cottages were built. Towards the turn of the twentieth century, Tudor Street was described as 'a populous working-class district', and so when it came to knock it down, the civic planners ruled that 'nothing of historical or architectural interest' would be found in such an area.

As the bulldozers moved in and the wrecking crews rubbed their hands, rare seventeenth-century wall paintings were found hiding beneath years of accumulated wallpaper and paint, as were elaborate fireplaces, finely moulded oak mantels and other such historic curiosities. Unfortunately most of it was destroyed before it could be recorded for posterity, but some artefacts were salvaged and can now be seen in Abergavenny Museum.

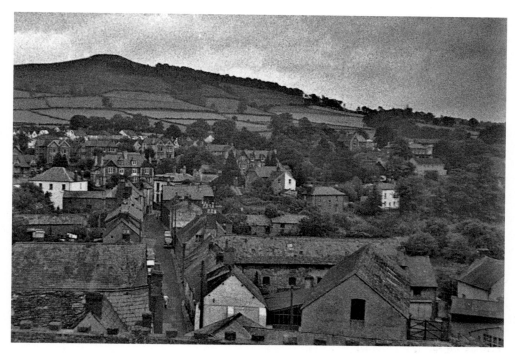

Mill Street, pictured from the castle just prior to the slum clearance.

Remembering the slum clearance in the book, *Abergavenny, in the Twentieth Century*, a contributor, who shall remain nameless to spare their blushes, writes in a fatalistically poetic fashion how the 'terrible slums' of Tudor Street desperately needed demolishing for the welfare of their poor inhabitants: 'Here [Tudor Street] they existed in indescribable poverty and misery. Owing to the narrowness of the alley, one side was always in the shadow of the sun. Their only joy in life was the thought of death to remove them from the squalor.'

Those born and bred in the area would no doubt beg to differ. Former Mayor of Abergavenny Norma Watkins was one such person. In an oral history interview with the team behind the Forgotten Abergavenny project, Norma recalls her grandmother was 'spitting feathers' at being forced from her home, in the 'roughest, toughest, street in town', but where the 'sense of community was absolutely unbelievable'. Norma remembers,

You had to move. You had no choice. Because in those days there wasn't any real notion that you could take them to court or stop them doing any of this stuff. Some houses were owned by them: it was compulsory purchase and you had no choice. You were out. They condemned the houses, wholesale. They condemned them and said that's it, they're not fit to live in, you've got to go. This is how they broke the community up. They didn't move, say, a block of houses all together and keep the community together; they just moved them and scattered them. I think they wanted to break Tudor Street apart.

DID YOU KNOW?

When Abergavenny's St John's Church was converted into a grammar school by order of Henry VIII in 1542, the remains of people buried in the churchyard were still stored in the large cupboards on each side of the entrance (under the tower) into the school. For generations kids attending the school couldn't resist a sly peek at the human skulls and bones gathering dust in the makeshift charnel houses in what may not have been a Catholic education, but certainly a Gothic one. The school was subsequently turned into a Masonic Lodge in 1898.

The job centre, the magistrates' court, and the police station all lined up like a pretty row of boxes in the Tudor Street of today.

3. The Abergavenny Kaiser

He was once Deputy Führer of Nazi Germany and next in line to Hermann Göring as the chosen candidate to step into Hitler's shoes in the eventuality of the diminutive dictator's death.

The ardent and diehard Nazi Rudolph Hess, whose regular doctor in Germany thought 'mildly psychopathic', was even responsible for typing up, some say co-authoring, *Mein Kampf* while being held in Bavaria's Landsberg Prison alongside Hitler after the failed 1924 Munich Putsch.

Yet after a doomed flight to Britain embarked on by Hess on 10 May 1941, where he flew solo some 1,000 miles across the North Sea to Scotland in the hope of meeting the Duke of Hamilton to negotiate a peace between Germany and Great Britain, Hess was forced to bail out by parachute near the village of Eaglesham, taken into army custody, and later transferred to Abergavenny's Maindiff Court Hospital, where he became known by local people as simply the 'Kaiser of Abergavenny'.

DID YOU KNOW?

Col. W. D. Steel's book *On the Western Front*, dealing with the record of the 3rd Monmouthshire Regiment in the First World War, states that, 'The Abergavenny company wore bulldogs on their shakos, and were known as the "Bulldogs", a nickname due to a special breed of dog peculiar to the town. I can just remember the last of these dogs owned by the old town crier. At his death the strain died out.'

Abergavenny man Joe Clifford was one of the guards responsible for looking after Hess during the entirety of his time at Maindiff Court and revealed in a conversation with this author how the captive Nazi walked with a semi-goosestep, tried to stab himself to death, frequently visited local pubs, enjoyed walking in the surrounding hills, and was indirectly responsible for a young Joe meeting the woman who would later become his wife.

On 16 May 1941, not long after Hess had landed in Scotland and given his name to the local home guard as 'Alfred Horn', the editor of the *Abergavenny Chronicle* wrote that Hitler must be a regular reader of the *Chronicle* as he'd sent the paper an advert for the agony column, which, in the national interest, he'd been unable to accept. The message read, 'Rudolf, return immediately and all will be forgiven – Adolf.'

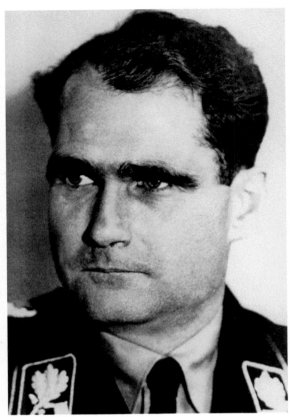

Above left: Joe Clifford.

Above right: A Picture of Rudolph Hess from the German Federal Archive.

Little did anyone in the sleepy market town of Abergavenny know that a key player in the Third Reich, who once quite ridiculously and in all earnestness stated that 'Adolf Hitler is simply pure reason incarnate' would soon be living in the Gateway to Wales.

Hess was transferred from Mytchett Place to Maindiff Court on 26 June 1942 after Abergavenny was recommended as a quiet place where the leading Nazi could have more freedoms. Joe Clifford, who was one of Hess's guards at Mytchett Place, was transferred with Hess to Maindiff Court and recalled,

Mytchett Place was a quiet country house with big grounds and was on the edge of Pirbright shooting range. There were over a hundred guards, not counting six RAMCS and the officers, trenches and barbed wire everywhere, and a sentry post. It was quite a surprise when we first got there to realise who we were responsible for guarding. I remember one of my first impressions of Hess was how tall he was, the arrogant manner in which he held himself, and the way in which he usually walked with a semi-goosestep, throwing his feet out. He seemed to be of the opinion that we were more his servants than his guards.

Abergavenny's unmistakable town hall pictured from the grounds of the castle.

Originally from Manchester, Joe was delighted with his new residence at Maindiff Court:

> I was born and bred in the heart of industrial Manchester, so to me, Abergavenny was such a beautiful part of the country to come and live. As for Maindiff Court, it is still much as it was. Hess was in a wing about 200 yards from the main road. As you went into the hospital, Hess and the people looking after him were on one side of the building and wounded soldiers from Dunkirk on the other.

Joe added,

> Hess had the best of treatment and the best of food. He was not on rations and had all the finest stuff from places in town like Vin Sullivan. He had two rooms, a bedroom and a sitting room. I would be stationed right outside his door, but I wasn't allowed to go or look inside. His rooms opened onto a veranda and from there onto a garden area that had previously been a tennis court. There were railings all the way round the garden area, and there was a locked gate. He had a pleasant view from the garden and could see a fair distance... At night I would be posted outside his bedroom and sometimes Hess would come out of his bedroom and walk into the garden. I would walk behind him, but he would never talk to me. He was a rather haughty and aloof man and I think he felt the likes of me were beneath him. In fact even though he could speak English, he very rarely spoke, expect to the officers who he sometimes dined with. He never talked to any of the guards.

Joe, who would literally see Hess every day during his time at Maindiff told the *Chronicle*,

Most days Hess would sit on the veranda reading, writing and drawing. He would normally wear a blue sports coat, grey flannel trousers, and sandals in the summer, and in the winter a long blue overcoat. Now and again he would dress up in his uniform - the uniform he flew over in from Germany. He was quite often taken to various beauty spots around Abergavenny in the car for a walk around. The Sugarloaf and Whitecastle were his favourite places. He seemed quite taken with the Welsh countryside. Two RAMC blokes would be walking twenty yards behind him and an officer alongside him. He would go to the Walnut Tree Inn when it was very quiet in there and when nobody was about. Some people say he visited other Abergavenny pubs, but I don't know anything about that.

Interestingly enough, Joe met a member of the secret service after the war who told him they always used to keep an eye on Hess when he was out and about. Joe explained, 'Even though there was nothing in the local press everyone in Abergavenny knew Hess was staying in the town. People used to see him in the country going for a walk. He never had trouble nor was he shouted at or abused by any of the locals as far as I know.'

Maindiff Court as it looks today.

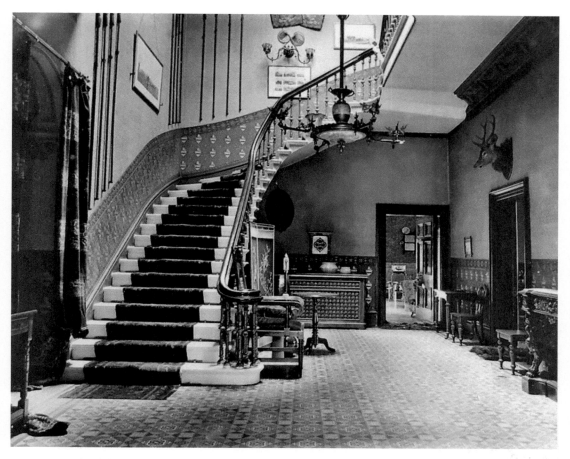

The interior of Maindiff Court as it would have look in Hess's day. A lot different to the normal POW experience.

During his time in Maindiff Court, Hess felt the tide of insanity lapping around his feet in the form of paranoid delusions and amnesia. A condition that seemed to be aggravated as more and more reports flooded in about Germany's growing unlikelihood of winning the war.

Hess was also probably remotely aware on some level that he and the rest of the leading Nazis would probably be tried for their lives when the war ended. Yet any indication of the Nazi's bizarre behaviour went unnoticed by Joe: 'Personally I never saw Hess behave in a strange way. I never observed him speaking to himself, or staring strangely. I do know that in February 1945 he made a suicide attempt by stabbing himself twice with a bread knife, but he only scratched himself with it.'

On 8 October of that year, Hess was flown to Germany to await the Nuremberg trials and Joe never saw the Abergavenny Kaiser again. 'Hess flew to Nuremberg from an airport this side of Hereford. We didn't know he had gone until we found reporters outside the gate of Maindiff,' revealed Joe.

DID YOU KNOW?

During the Second World War Spitfires could often be seen and heard training in the skies above Abergavenny, but on the morning of Sunday 8 March 1942 at exactly 10.35 a.m. the town saw and heard the most terrible of sights as twenty-six-year-old pilot Reg Crowe of Wallasey in Cheshire lost control of his plane during a dive and crashed into the flanks of the Skirrid Mountain.

When Hess arrived at Nuremberg he was, in the words of German historian Joachim Fest, 'Far from his God (Adolf Hitler) and the dispensation of blessings, for which he had always been so avid, he was a mere ghost of himself. Those who met him again at Nuremberg saw a face burnt out by its former ecstasies and the torture of excommunication.'

Retired medical superintendent of Maindiff Court Dr N. R. Phillips told the *Chronicle* in 1945,

In my experience Hess's strongest delusion was in regard to the Jews. He regarded them as responsible for all the troubles in the world. He thought they exercised a hypnotic influence over everyone and had a hand in everything unpleasant that happened, even to himself. Hess even blamed the Jews for his removal to Maindiff Court. Sometimes he would imagine his food was poisoned by the Jews and that the noises on the nearby railway line were made by Jews to annoy him. During his periods of insanity Hess would appear to hear voices all around him and he would turn his head quickly and shout at some imaginary person. He would become irritable and autocratic and order people about in the true Nazi manner.

Dr Phillips added, 'Despite his periods of mental disturbance, Hess could argue coherently, interestingly and intelligently, but it was palpable that his arguments were based on delusions and false premises which indicated his state of mind. However, he was able to appreciate the difference between right and wrong.'

After listening to horror after horror perpetrated by the Nazi regime during the Nuremberg trials, Hess's final words to the court as his eyes starred distantly into some private void were, 'It was granted to me for many years of my life to live and work under the greatest son whom my nation has produced in the thousand years of its history. Even if I could, I would not expunge this period from my existence. I regret nothing.'

Meanwhile, back in Britain, Hess's former guard Joe Clifford went to Preston to be demobbed after VE day and returned to Abergavenny to marry his wife, local girl Muriel Clifford, with whom he had a son named David. After the war Joe got a job at Pen-y-Fal, where he worked until he retired. Joe told the *Chronicle*, 'I never missed Manchester at all and was so happy to settle in Abergavenny. It was where I met my wife and started a family. So in a funny old way, if it hadn't been for Hess I may never have come to this neck of the woods and my life would have been completely different.'

Abergavenny's old soldier in Frogmore Street stands in perpetual guard over the Gateway to Wales.

As for Hess, he was sentenced to life imprisonment in Spandau Prison, where conditions were a lot harsher and the regime a lot stricter than Maindiff Court. After the release of Hess's fellow Nazis, such as Alber Speer in September 1966, the aging Hess spent the remaining twenty-one years in solitary confinement as the sole prisoner of Spandau.

Hess finally took his own life on 17 August 1987 by hanging himself. Within days of his death, the demolition of Spandau commenced, for fear of it becoming a shrine to neo-Nazis. Joe said in conclusion, 'I think that Hess must have always remembered Abergavenny, because compared with other places, he was always well treated and had a lovely time here.'

DID YOU KNOW?

Abergavenny's Skirrid Inn was once used as a court by infamous 'Hanging' Judge Jeffery. The resulting executions were also conducted there by hanging those found guilty from a beam above the stairwell. One of Jeffery's victims is said to haunt the inn as a one-legged ghost. Apparently he escaped his appointment with the noose by stabbing himself.

4. The Day the Beatles Came to Town

As legendary concerts go, it's not really in the same league as when the Beatles played New York's Shea Stadium in 1965. However, for the 600-plus people in the audience when the moptops played Abergavenny on 22 June 1963, it was destined to be written into the town's folklore. Especially because John Lennon became the most famous person ever to grace the hallowed turf of the 'Welsh Wembley' when he landed by helicopter at the Pen-y-Pound Ground of the now-defunct football team, the Abergavenny Thursdays. The Thursdays, who in 1963 were battling it out with giants of Welsh football such as Cardiff City FC, were the only team in Britain, apart from Sheffield Wednesday, to be named after the day of the week on which they first played their games, but we digress.

The real reason Lennon arrived later than Paul, George, and Ringo, was not because the Scouse songbird had high hopes of seeing the men in green in action, but because he was late for the gig as a result of recording an episode of *Jukebox Jury* in London for the BBC. Lennon didn't finish filming until 9.15 p.m. and was instantly ferried to Battersea Helipad from whence he was transported to the Gateway to Wales in a manic race against the clock in a bright yellow chopper.

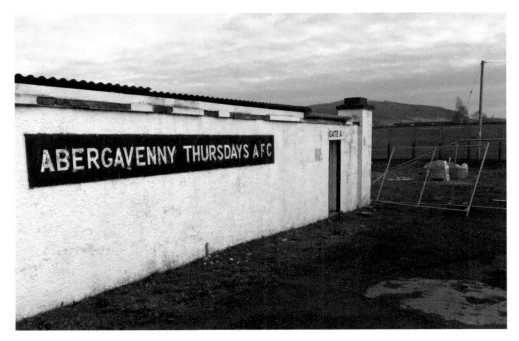

Outside the home of the Abergavenny Thursdays where Lennon arrived by chopper.

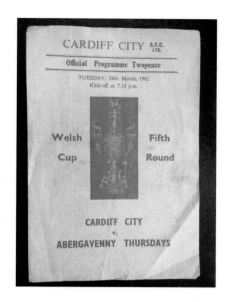

The Thursdays welcomed the Bluebirds to Pen-y-Pound a few months before Lennon.

Consequently Pen-y-Pound pulled its biggest crowd of the season as hundreds of people, including many small children, packed into the playing area to wait for the arrival of Lennon and grant him a hero's welcome, before he was bundled into a taxi and rushed to the town hall. After arriving Lennon said, 'This is the first time I've flown in a fish. It was just like sitting in a flying armchair, with only a piece of glass in front of you. But it was very cold up there.'

Paul, George, and Ringo had earlier made the journey by road and were granted the rare rock 'n' roll treat of a civic reception hosted by Abergavenny's mayor and mayoress. It was Macca's twenty-first birthday a few days before the concert and on the night he was presented with a huge birthday card signed by hundreds of those present. The card was given to him by Miss Lorraine Tattersall.

Although riding the swelling crest of a wave caused by the dynamic ripple of having 'Please, Please Me' reach the number one spot in early 1963, the Beatles were nowhere near the global pop phenomenon they would later become. Yet they were already commanding twice the fee their manager Brian Epstein had agreed (£250) with Abergavenny promoter Eddie Tattersall in April of that year.

Although the helicopter itself cost Epstein more than £100, the band agreed to honour the booking, and were supported by local act The Fabulous Fortunes. The Beatles finally appeared on stage at 10.30 p.m. and, in a set that lasted over an hour, rocked the rafters doing what they did best.

The 'Boy from Tudor Street' Meets the Beatles

Many of the men in the audience the night the Beatles rocked Abergavenny had suits made to measure at Abergavenny's Burtons just for the occasion, and a certain sharply dressed 'local boy from Tudor Street' got the opportunity to hang out with the Fab Four before and after their legendary gig. His name is Bryn Yem and he's affectionately known as the most famous unknown singer in Britain. Bryn has sold over a million records since the 1960s and

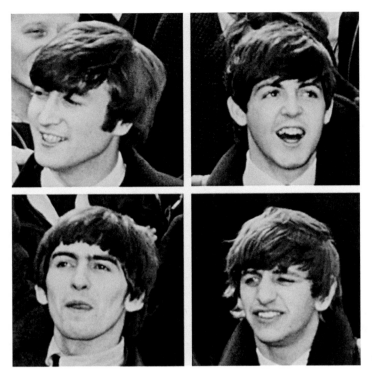

The moptops.

The distinctive Burton's
sign in Abergavenny's
Nevill Street.

has earned himself a prestigious place in the *Guinness Book of Records* as the only UK artist to have three albums in the charts in the space of one year. Not bad work for an Abergavenny lad who was given away at a Brynmawr bus stop when he was just nine months old.

'It may sound like a wild boast, but just before the Beatles played here, I was probably a lot bigger in the town than they were', reveals Bryn, who at a very youthful seventy-something looks and sounds like someone who has spent most of their life in the world of showbiz. And yet Bryn, who was once famously dubbed the 'Welsh Bruce Forsyth' might have been a household name on par with the likes of that other larger than life and gruff-voiced raconteur Tom Jones, if only the Abergavenny songbird had accepted the Beatles manager Brian Epstein's invite to visit him in London all those years ago.

Bryn explained, 'At the time the Beatles played the Town Hall, I was more a fan of the Hollies, who thanks to promoter Eddie Tattersall, also played Abergavenny. I mean I had heard the Beatles' debut album 'Please Please Me', and although I liked it, it hadn't blown me away.' Bryn added,

I was invited to the Town Hall to meet the boys by the Mayor of the time, Jack Thurston, who knew me as a local entertainer who performed regularly in the area. I arrived at the Town Hall quite early and got to hang out with Paul, George and Ringo. I remember getting on really well with all of them especially Ringo, because we were all the same sort of age and enjoyed the same sort of banter. I recall that when John Lennon finally arrived after being flown by helicopter from London to Pen-y-Pound, the other three greeted him with some sarcastic comments about being late because he had been filming

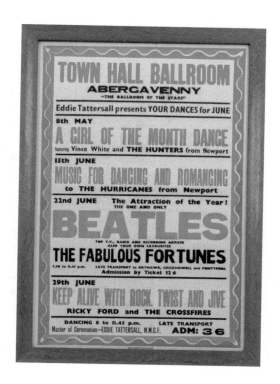

A poster advertising the Beatles gig.

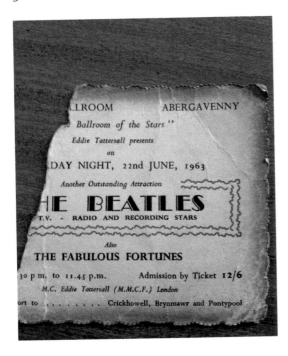

A ticket from the concert.

an episode of *Jukebox Jury*, but he gave as good as he got and even then you could already see the close-knitted gang mentality which they became renowned for.

After the gig Bryn accompanied the Beatles to the Angel Hotel and said, 'Later that evening I was introduced to Brian Epstein by Jack Thurston who said to the Beatles manager, "This is Bryn, a local pop star and good lad". After chatting with Epstein for a while and with Jack constantly in the background singing my praises, Brian eventually said to me, "Why don't you come and visit us in London and perhaps we can do something together".'

A rueful Bryn explained, 'At that time I didn't have the money to go, besides which, back then, to a simple boy from Tudor Street, London might have as well have been another country. However, if I had known then what the Beatles achieved under Epstein's management, I would have perhaps made more of an effort to have packed up my bags and gone.'

DID YOU KNOW?

When the moptops came to town, not everyone was a fan. Rumour has it that a local character by the name of Bunker had a disagreement with chirpy Scouse songbird John Lennon and ended up bopping him smack on the nose before doing a runner. It's doubtful if the assault in Abergavenny inspired Lennon to later pen the classic 'All You Need Is Love', but you never know.

Baby You Can Drive My Car

In the book *The Beatles 'I Was there'*, Aveline James recalls,

My father had the Esso garage on the Hereford Road at the time and the following day they just happened to pull in to the garage for petrol. So, to my surprise, dad came to tell me that Paul and John had come in for petrol, so I had the great pleasure of meeting them briefly and getting their autographs, which I later gave to my younger brother to take to school and show his friends some years later. Unfortunately they did not get back home with him and to this day I do not know who took them. I still don't know what happened to those autographs. My brother now has to live that down every time we get together.

Ticket to Ride

A chair celebrating the evening the Beatles played in Abergavenny was accidentally discovered by a former resident of the town when window shopping on the other side of the world. The curious chair was found in the town of Mittagong, which is located in Australia's New South Wales and is often referred to as 'the Gateway to the Southern Highlands'. At the last count in 2006 the little town down under only had a population of 7,460 people, which makes it all the more surprising that a chair with such a unique Abergavenny connection was found in the back end of beyond.

The chair is lovingly upholstered with rare poster designs boasting the renowned events Abergavenny's Master of Ceremonies Eddie Tattersall used to organise at the town hall, including the famous appearance by the Beatles.

A chair with a story.

The woman who found a little nostalgic slice of her home town sitting pretty in a Mittagong shop window was Jackie Sampson, who has been living in New Zealand for the previous decade and was visiting her near neighbours in Australia. Jackie's mother Mrs Sampson explained, 'Jackie couldn't quite believe it when she saw it. I mean, what's the chances of a person from Abergavenny bumping into a chair like that in a little town in Australia? She dearly wanted to buy it, but the shop wanted 479 dollars for it, so she couldn't quite afford it. So she took a picture instead which is the next best thing.'

DID YOU KNOW?

In Cockney rhyming slang when a pearly king uses the word Abergavenny, they are apparently making a reference to an old penny. Maybe that's why when London-based hip-hop artist Roots Manuva mentions Abergavenny on his song 'Get U High' from his 2006 album *Alternately Deep*, the exact lyric is, 'Burn every penny on trips to Abergavenny.'

Lend Me Your Comb

Less than a year after the Fab Four played the town, Beatlemania had well and truly taken the world by storm, but it would appear someone forgot to tell the headmaster at Abergavenny's King Henry VIII School. In an edition of the *Abergavenny Chronicle* from 8 May 1964, it's reported how a small number of pupils were banned from competing in sports events with other schools until they got their 'Beatle-style haircuts' trimmed. Apparently at one time around fifteen lads in the school wore their hair like John, Paul, George, and Ringo but were forced by the powers that be to 'toe the line.'

Yet in keeping with the spirt of the '60s, four boys stood their ground, refused to buckle, and told the man to do one, 'The man' in this instance being the headmaster Dr D. G. D. Issac, who said, 'I have no quarrel with the Beatles. Their standard is all right where the Beatles are active. But it is not a standard which should be brought into schools. Our school compares very handsomely with other schools, both in uniform and bearing. We must do our best to uphold this reputation.'

Dr Isaac added that the boys who wore their hair like the Beatles were 'overlapping the bounds of what is reasonable and looked ridiculous. They are displaying extreme masculine vanity, and it could incite unfavourable comment from outside.' As well as slamming 'extravagant hairstyles' the good Dr Isaac was also extremely concerned at the types of shoes some pupils were wearing. Particularly 'the long, pointed-type', which he planned to ban on health grounds. The poor doctor, if only he knew what was around the corner later that decade.

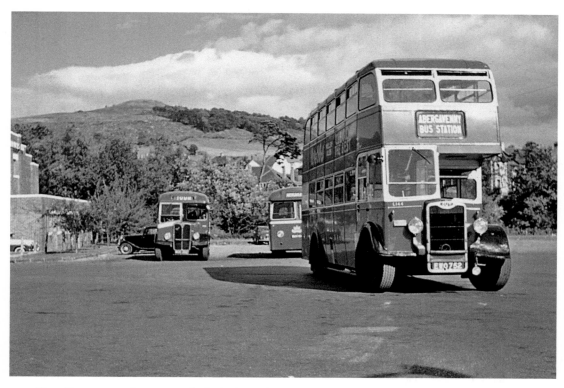

How Abergavenny bus station looked when John, Paul, George, and Ringo came to town.

DID YOU KNOW?

In the book *Harry Potter and the Prisoner of Azkaban* the Knight Bus stops at Abergavenny and in the *Danger Mouse* episode, 'The Four Tasks of Dangermouse' it is mentioned that a Penfold has an aunt in Abergavenny.

5. The Abergavenny Asylum

Many moons ago in the South Wales valleys, if someone enquired after someone and were told that the person in question had 'gone to Abergavenny', then it meant something very different than to what it does today. The phrase 'gone to Abergavenny' was a metaphor for going insane and being committed to Pen-y-Fal Lunatic Asylum – the sprawling Tudor Gothic-style building that overlooked and cast a shadow over the Gateway to Wales for well over a century.

Today, of course, the once notorious 'madhouse' has been converted into a homely housing estate, but for many the history of Pen-y-Fal, what it symbolised, and the largely forgotten tales of the thousands of poor souls who passed through its imposing doors have left an indelible mark.

Originally known as the Joint Counties Lunatic Asylum, and later the Monmouthshire Mental Hospital, but more commonly known as the Abergavenny Asylum, Pen-y-Fal was erected in 1851 as a consequence of the 1845 Lunacy Act, which ruled that counties and boroughs all over the UK had to provide accommodation for the mentally ill.

Originally intended to house a maximum of 210 patients, the hospital was catering for well over twice that number by 1867 and subsequent extensions to the main hospital

No longer an asylum, Pen-y-Fal has since been converted into luxury apartments.

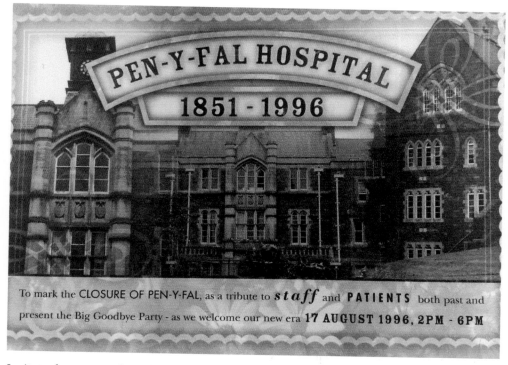

Invite to the party marking the end of Pen-y-Fal as the town knew it.

entailed, so that eventually Pen-y-Pal housed a staggering 1,170 inmates and covered 24 acres of ground.

The stigma and lack of knowledge surrounding mental illness was extremely primitive in the early days of Pen-y-Fal, and postnatal depression, alcoholism, senile dementia, or even infidelity, which was then classed as 'moral insanity', were grounds enough to have you committed indefinitely.

Abergavenny-man and former psychiatric nurse David Bowen, who worked at the hospital from 1965 until its closure in 1996, explained, 'What many people fail to remember is that nearly all the patients who ended up in Pen-y-Fal, especially during the early days, were put there by their own family. All they needed was two doctors willing to sign certificates of insanity, and embarrassing or inconvenient relatives could be detained for God knows how many years.' In particular, women, especially women with little money and of low social status, were prime candidates for a tenure in Pen-y-Fal and similar Victorian establishments. 'Hysteria' is taken from the Latin word for 'womb' and many medical men of the Victorian era were gung-ho to identify hysteria in all forms of female behaviour – such as excited chattering with friends for example. Erotomania (hypersexuality) was also considered a constant danger in female patients of the Victorian era and was thought to accompany hysteria.

In 1855 a report by a medical superintendent at Pen-y-Fal reveals that since 23 June 1854 over 129 patients were admitted. Sixty-three of them were subsequently discharged

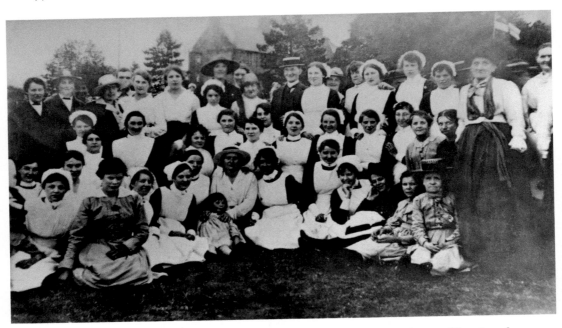

A picture of staff and patients as Pen-y-Fal that was once strangely popular as a 'Greetings from Abergavenny' postcard. In the front row you can see one of the many children who were born into care at Pen-y-Fal.

and over forty-five died. One cause of death in an epileptic patient was returned by a coroner as 'Died by the visitation of God.' The report also states that the asylum currently housed 115 men and 151 women and although the male patients were generally tranquil, several of the women were disorderly. The document also shows that epilepsy and 'causes unknown' far outweighed all other forms of admission, which included desertion, disease of brain, disappointed love, drink, fright, grief and over anxiety of mind, hereditary and congenital causes, injury to head from falls and other violence, jealousy, pride, and religious subjects. Mr Bowen said,

When I started in 1965, Pen-y-Fal was a lot different to when the first ever patient, Timothy Matthews from Hereford, walked through the doors, but it still was a place where a lot of troubled souls suffered terribly. Having said that, Pen-y-Fal embodied the changes in the philosophy of treatment in regard to mental illness. In the early years they would seek to control the patients with chains, shackles, ECT and brute force, but in the latter years there was less emphasis on control and more on care and cure via counselling and drugs. Consequently, the only logical conclusion to a place like Pen-y-Fal was to close it down in favour of 'care in the community'. A scheme which in many ways was the only 'happy ending' to the years of darkness and ignorance surrounding mental illness. Now, Instead of locking people away with other 'mad' people so we can conveniently forget about them or pretend they don't exist, they can now, thanks to significant advancements in psychiatry and understanding, live in 'our' world.

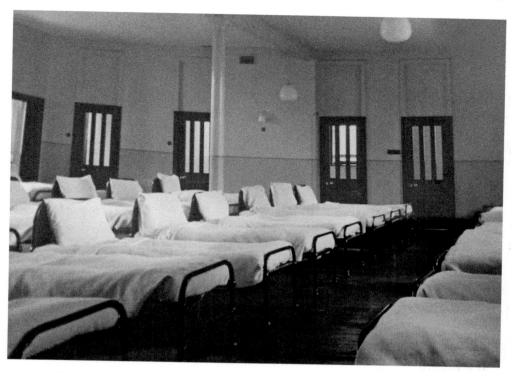

Above and below: Sobering views of a typical Pen-y-Fal ward when a patient's privacy wasn't high on the agenda.

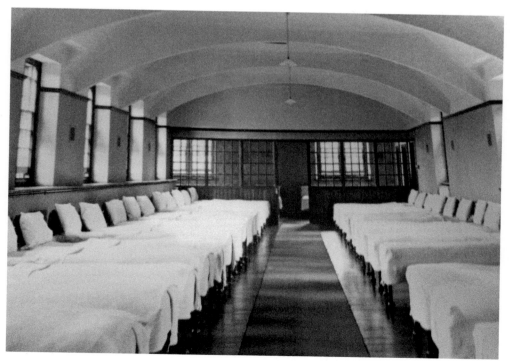

An *Abergavenny Chronicle* report of a 1908 inquest held at Pen-y-Fal to determine the cause of death of thirty-one-year-old Edith Mary Barnes gives a poignant snapshot as to the plight of the poor souls who often ended up in the Abergavenny Asylum:

Sarah Walters, mother of the deceased, told the coroner that her daughter had previously attempted to kill herself after trying to cut her throat with a pair of scissors on April 8. The mother scolded her for her wickedness to which the deceased replied that God had told her that she must die, and she implored her mother to let her kill herself. She then added that she must go to Hell and God would show her the way to do it. The mother told the inquest that she put it all down to the weakness natural to her then condition and simply told her she should be ashamed of herself. The doctor was called and gave her a draught and put her to sleep. The next morning he returned and said she was getting a long all right. He then performed an operation. After that she seemed to be quite in her right mind until two days later when she set herself on fire. The incident occurred on April 10. Her husband was just dozing off when she awoke him by getting out of bed. He then saw her walk across the room, before tipping the lighted paraffin lamp so as to spill the oil over her night dress and set herself on fire. The girl's mother

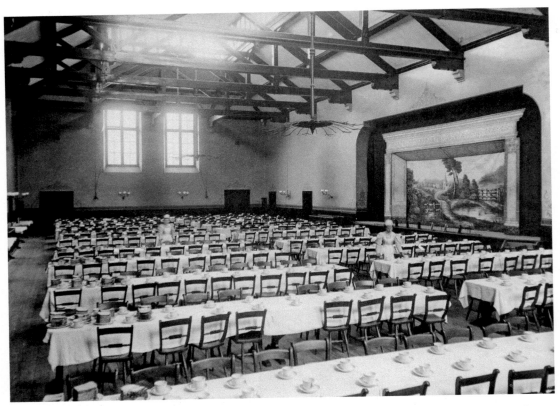

Pen-y-Fal's huge main hall. At one time it was the biggest function hall in Abergavenny until Redrow Homes demolished it.

came to Mr Barnes's assistance and together they extinguished the fire. The deceased was admitted to the asylum the same night, but after treatment, died on April 16 as a result of the shock caused by the burns and the suffering caused from perpetual pain. The primary cause of death was given as exhaustion.

From the Cradle to the Grave

A pensioner committed to Pen-y-Fal at the age of five who was still a resident seventy years later told the *Abergavenny Chronicle* in 1978 that even after all that time, 'He wouldn't leave his "wonderful home" for the world.' Albert White was assessed as mentally ill and taken from his home in Tudor Street in 1902 to become a member of the 'family' of 1,350 inmates who resided at his new home. Kept in relative isolation, with the exception of contact with his mother who subsequently moved to Portskewett, Albert grew to manhood with little to no experience of life outside of a self-contained community.

DID YOU KNOW?

Abergavenny's Pentre House was famous for a notorious robbery back at the beginning of the nineteenth century when the family silver was taken. The aforesaid said silver turned up in Tudor Street's The Bluebell Inn and the landlord was transported to Australia as punishment.

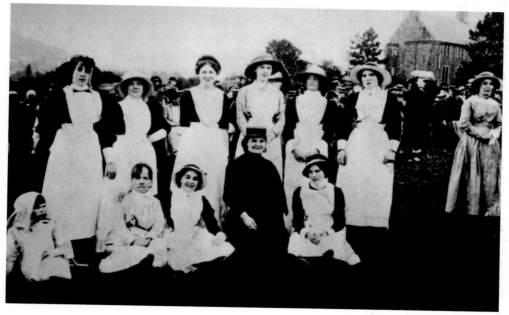

A group of nurses at Pen-y-Fal.

Life was tough and regimented for Albert. When he arrived the inmates wore a dour and coarse uniform of heavy boots, thick corduroy trousers and rough serge jackets. Males and females were completely segregated, conditions were strict, the environment Spartan, and chores were many and demanding.

However, the new Health Acts introduced a change of both approach and environment. By the time the 1970s rolled around, Albert, like many others, was living in the security and comfort of small family groups and enjoying frequent trips into town and regular outings to the seaside. Albert explained, 'When I first came here they used to call us lunatics. Now I am a resident and this is my home.' Although Albert harboured no sense of bitterness that his entire life had been governed by an institutionalised regime, you cannot help but wonder what madness drove grown adults to think it was ever a good idea to pluck young children from their families and commit them to life sentences in such places.

Inmates and Stalemates

When Pen-y-Fal Hospital finally marked its closure for good on 17 August 1997, Ray Batten, who spent eighteen years on the wards as a charge nurse and seven years as a nursing tutor, recalled the time he was taught to play chess by one of the patients.

Second World War veteran Ray explained how one day when he was working as a nursing tutor at Pen-y-Fal he had found a chess set in the hospital. Eager to play but not knowing the rules, Ray asked the patients of Male Ward 6 if any of them knew how to play chess. To his surprise a patient simply known as Nobby agreed to verse Ray in the art of the ancient game. 'I remember Nobby's voice was very hoarse at the time from his recent manic attack,' revealed Ray. 'He'd been confined to the side room for a week, uncontrollably hyperactive, gabbling nonsense, sleepless and difficult to feed. It was a wonder he didn't die from exhaustion.'

Yet inside a ward ripe with the smell of fish pie, Nobby taught Ray the rudiments of chess, much to the charge nurse's displeasure: 'The charge nurse was a stern, intense man who never smiled and he was against Nobby teaching me to play chess and said, "You'll get friendly and if we have to restrain him, you won't like doing it".' Yet despite the warning, Nobby and Ray were left to their own devices, and word soon spread of the Pen-y-Fal patient's mastery of the sixty-four squares.

As respect for the burgeoning chess master grew, more and more people wanted to play him, until one evening the charge nurse, who was something of a keen chess player himself, professed a desire to play the inmate. Ray remembers the showdown as an 'intense battle for supremacy' where Nobby was in a 'lose-lose situation'. 'The charge nurse's self-image of superior intelligence would be bruised if Nobby beat him, but if Nobby lost it could damage his new found self-esteem.'

Staying up past the 8.30 p.m. bedtime for patients, Nobby sat hunched over a small table locked in a battle of mental prowess with the charge nurse, and then at ten minutes to nine, 'Nobby moved his Queen. "Checkmate!" The CN's face reddened ... the sting of defeat hurt. "What now?" I thought and tensed for his reaction. Suddenly "his face relaxed and he congratulated Nobby on his win with a new respect creeping into his voice. They played many more games together and I believe became friends. To my knowledge Nobby never had another manic attack".'

As the old Chinese proverb said, 'Life is like a game of chess, changing with each move.'

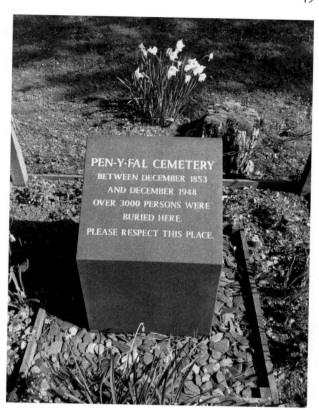

PEN-Y-FAL CEMETERY
BETWEEN DECEMBER 1853
AND DECEMBER 1948
OVER 3000 PERSONS WERE
BURIED HERE.
PLEASE RESPECT THIS PLACE.

The only sign that stands today to indicate what this area of Abergavenny once was.

DID YOU KNOW?

When Abergavenny's old drill hall in Baker Street was converted to a cinema in May 2010, the owners paid tribute to the name of the location by making sure the first film shown was *Sherlock Holmes*. Less than two years later, the cinema hosted the Welsh premier of the film adaptation of local author Owen Sheer's book *Resistance*, which just happened to be attended by a bloke called Prince Charles.

DID YOU KNOW?

Steel's Memorial, which is now submerged in the River Usk with only the railings surrounding it left above water due to bank erosion, was ironically built to commemorate the son of well-known local medical man Dr Steel, who drowned at that point in the river.

6. The Great Scandal of 1942

In 1942 the author J. R. Ackerley wrote a letter to the *Spectator* expressing his outrage in regard to a story he had stumbled across that took place in Abergavenny. The story concerned a number of men who were involved in a notorious sex case that made national news and 'rattled the town like an earthquake.' Ackerley was himself gay in a time when homosexuality was still an imprisonable offence, and made his protestations on the basis that over twenty men were put on trial for homosexual behaviour. One of the men involved took his own life by throwing himself in front of a train, while most of the other men involved received sentences ranging from one to ten years.

While it is indisputable that lives have been cut short and damaged by the criminalisation of homosexuality, the question that must be asked is: Did Ackerley have the full facts at his disposal in regard to the Abergavenny scandal of 1942? Or did he choose to ignore certain extremely disturbing elements which would still carry a prison sentence today?

For example, the judge in the case had no hesitation in describing some of the men involved in the case as 'principals who corrupted youths'. Such men's defining sexual

The Abergavenny of yesteryear.

characteristic was that of a predatory male, which, had they been heterosexual, would have been equally as damming.

Under the editorship of a tenacious newsman named George Harris, the *Abergavenny Chronicle* covered the proceedings and trials more extensively than any other media outlet. Below is a brief summary of events as they unfolded.

June 19: Seven persons are brought up on serious charges under the Offences Against the Person Act. Their names, age, occupation, and charges include: George Rowe (forty), cinema manager, gross indecency; James Taylor (thirty-nine), chef, gross indecency; Percy Turner (thirty-seven), hotel chef, gross indecency; James Duffy (twenty-seven), cafe assistant, gross indecency; Oswald Pugh (twenty-seven), hairdresser, Sodomy; Neville Holly (thirty-one), clerk, sodomy.

It was reported that Holly was arrested in Scotland earlier that month. All men were refused bail, except Rowe who made a failed suicide attempt in his own home, about which he later said, 'I can't stand the scandal. That has always been the trouble with me. I haven't got any guts.' Another man arrested in relation to the same charges had since died on 12 June.

June 26: The *Chronicle* reports that a nineteen-year-old Abergavenny man, who was previously detained at the town's police station but later released on bail on June 11, went on to commit suicide in the early hours of the next day. The man, who placed his head upon the outside line of the Abergavenny–Penpergwm track, had his skull split open and brain lacerated by a passing train. At the inquest it was heard that on the inside breast pocket of the deceased's jacket was a note addressed to his work mate, which the coroner refused to read, but stated it was sufficient for him to say that it indicated quite clearly the intention of the deceased to destroy himself with regard to the fact he was in some trouble.

Three more people were also arrested this week on serious charges, two of which were arrested in London. One of the aforesaid men, who was discharged from the army for having a complete nervous breakdown, said he expected a fair chance of being leniently dealt with at his trial and declared he had completely cured himself of his 'tendencies'. He also stated he was presently engaged at a theatre and worried that his absence would seriously hold up the promotion due to the shortage of actors.

July 10: Due to further arrests there are now nineteen persons in custody on charges under the Offences Against the Person Act at Abergavenny. Two of the men were from London, one from Barking, one from Cross Ash, one from Abercarn, and one from Gilwern. It is reported that the police are making continued enquiries further afield.

July 17: A week later a further two men in their forties are arrested. When arrested and charged in Abercarn, one of the accused replied, 'I know who the boy is, but I deny it.' Meanwhile, the man arrested in Abertillery replied when charged, 'That's a lie! I don't know him.'

July 31: The hearing of twenty-four men charged with grave offences commenced at Abergavenny this week. Twenty of the men were brought up on remand from Cardiff gaol, handcuffed together in pairs. One of the accused Oswald Pugh was unable to make the journey on medical grounds. One man had committed suicide in custody, one had received bail, and one was in custody waiting to be added to the list.

Abergavenny's old police station, which has now been converted into flats.

The sterile hand of modernisation has left some parts of Abergavenny blissfully untouched.

August 7: Five solicitors appeared at the Abergavenny Police Court this week to represent various members of the twenty-three accused. One twenty-year-old man who had been charged with an offence three years ago was discharged. After the solicitors complained that they had no time to properly examine the statements and prepare the case, a further adjournment date of August 17 was agreed.

August 21: Twenty-two accused men charged with a total of 192 offences were present at an Abergavenny Police Court this week for a hearing that lasted five days, and from which the public were banned. Mr Harmston in opening the cases said they would hear in almost every statement made, the defendant either admitted the offences or some of the offences, or would notice that these statements often referred to other defendants. Mr Harmston then went on to include the three types of offence, which included the actual offence, the offence of attempting, and the offence of soliciting.

In the case of Oswald Pugh, who was in a paralysed condition and had to be carried in and out of court, those present heard that a boy of sixteen said he went to Pugh's house and Pugh asked him to do something, which he did. Another boy of seventeen said he had met a man called Horace, whom he now knew as Pugh.

On meeting Pugh, the boy went for a walk down the river with him. There were others there at the time, and Pugh made a suggestion to the boy, but the boy did not respond. Around a month later Pugh asked him to go to his house and said he would give him some money, but the boy refused to go. Pugh said, 'I deny the charge of money.' In a statement Pugh said he had come to Abergavenny, and a few months later he had become

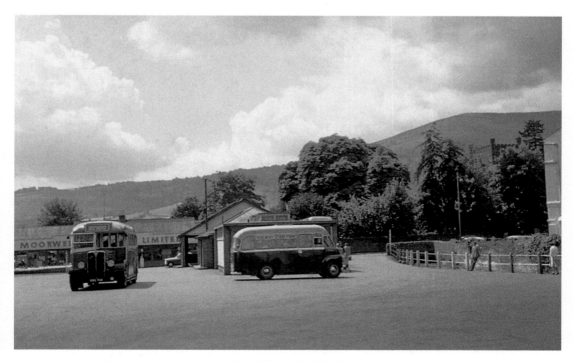

Abergavenny's transport system was a lot different back in the day.

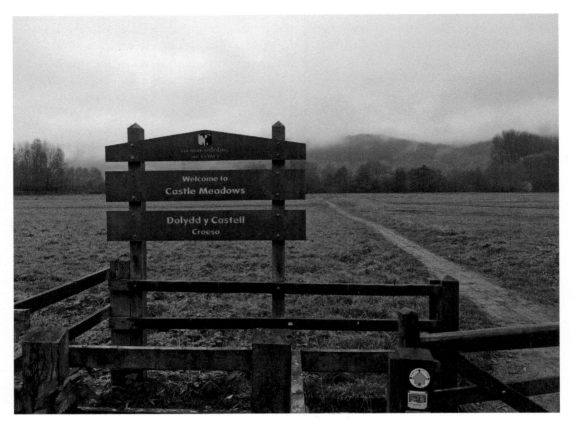

The men on trial were said to have taken many walks down Castle Meadows together.

good friends with James Taylor, and had made the acquaintance of several members of an army unit stationed in the area. He was introduced to boys and went for walks along the river, but never touched any, except one. In April he went for a walk with Taylor and Holly and they met two Indian soldiers, and Pugh said, 'I and Taylor took one each.' He could not remember the number of Indian soldiers he had been associated with, but it was somewhere between twenty-five and thirty.

In the case of Rowe, a boy of fifteen said that in June or July he was employed at the cinema that Rowe was the manager of. Soon after he started working with Rowe, one night Rowe told him he had a cold, but said that they could carry on working at his house, which was on the opposite side of the road. The boy slept at Rowe's house half a dozen times and once or twice in the same bed, before quitting his job. The *Chronicle* reports that the witness became very hesitant when being examined by Mr Harmston, who tried to get him to explain what happened, before saying, 'I am afraid I cannot put words into your mouth.'

Another boy of fifteen who had worked at the same cinema was given two flagons of beer and stout by Rowe, who told him that when his housekeeper was away, they would go to his house and he would show him a lot of things he had learned in France. The boy

did not tell his mother what had happened because he was too ashamed. When Rowe asked him why he did not come back to work, the boy told him 'you know why'. The mother of one of the boys said, 'What have you done to these boys.' Rowe said he thought the boy had left his position of employment because he wanted more money. Rowe said he offered the boy more money but he did not come back. The *Chronicle* reports how Rowe seemed noticeably nervous.

Yet another boy of fifteen who worked at the cinema said Rowe took him back to his house, gave him chocolate and told him not to tell anyone what had happened.

A sixteen-year-old boy said he had been at Rowe's house when a friend of Rowe put a tea cloth on his head, another cloth over his knees, combed his hair with a fork, called himself the Queen of Sheba, and talked like a woman.

In the case of Neville Holly, a boy of sixteen, had given evidence that he had met Holly at Rowe's house in September 1941, where a party were playing roulette and drinking intoxicants. Holly followed the boy out of the room and made a suggestion. A boy of

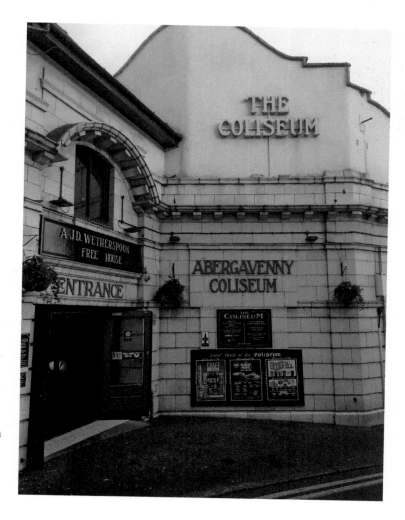

The Coliseum Cinema
that George Rowe
managed has now
been turned into
a pub.

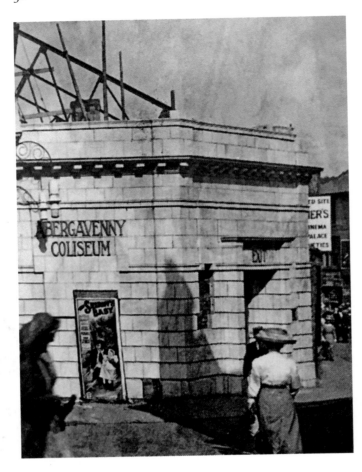

The Coliseum under
construction.

sixteen said he met Holly around May 1941 and gave evidence of two incidents. Another
boy of seventeen gave evidence as to two incidents in which Holly was concerned. A boy
of fifteen spoke of his association with Holly, and said that Holly's conduct grew worse,
and on one occasion he refused his suggestion. Holly made a statement that he had
become acquainted with Rowe and had a key to his house. He described how he also got
to know Hugh and Taylor, and knew that they were both frequently with Indian soldiers.
He told how he had watched them through opera glasses and Pugh had made a remark
about Holly being jealous because he had never been with an Indian. Holly said he was
introduced to this class of offence when he was fourteen or fifteen by an older local man.
Holly made a further statement saying, 'All the parties I have been associated with have
been consenting parties.'

In the case of James Duffy, a boy of sixteen said he had met Duffy in Bailey Park. Duffy
asked him to go a walk with him and tried to interfere with him, but the boy had started
to fight and Duffy ran away. Six months later Duffy asked the same boy to go for a walk
with him up the Little Skirrid, again Duffy tried to interfere with the boy, but the boy
stopped him.

Right: Bailey Park.

Below: People queuing
in Lion Street to visit the
Coliseum.

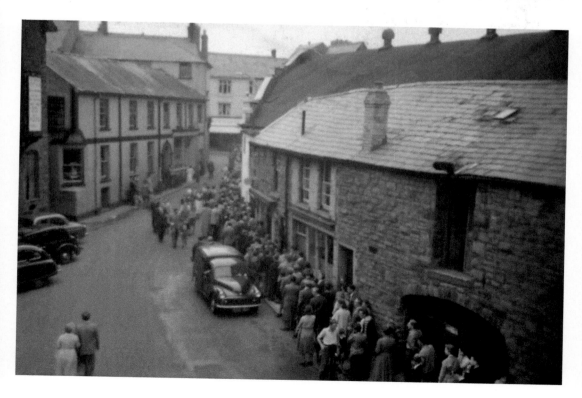

In regard to Frederick Percival Turner, a fifteen-year-old boy said that he had tried to interfere with him and promised him money. In a statement Turner admitted a number of offences at Abergavenny and a Newport hotel where he worked, and said he had paid a youth on various occasions.

One of the men who received a lesser sentence of fifteen months said in his defence, 'Yes, I can't say how many times it happened. What I did was of my own free will. It is in my nature, it appeals to me. Perhaps you are different.' Another man who was eventually discharged said, 'I have always been attracted to my own sex, and I have fought against it.'

Following a long line of lengthy statements, the court heard it should be explained that a good many of the alleged offences were not committed at Abergavenny, and that a number of the defendants had only a short or temporary connection with Abergavenny, being wartime importations.

Of the twenty-two men charged, nineteen were committed to the Monmouthshire Assizes, two were dismissed, and one was to be dealt with separately.

November 4: Twenty men committed from Abergavenny came before Mr Justice Singleton on grave charges at the Monmouthshire Assizes. Two were discharged, one was referred, and the remaining seventeen were put into the dock together, and each had a numbered label affixed to his coat to distinguish him. Only one case came before the jury, and only one witness was called, as the prosecution remained satisfied with the pleas of guilty in other cases.

In all a total of thirteen men received sentences ranging from twelve months to ten years, combining a collective fifty-seven and a half years of imprisonment. The remaining four were bound over for two years in the sum of £10.

Although the judge regarded Holly as one of the worst cases, it came as something of a shock to everyone in the court when the sentence of ten years penal servitude was announced. Holly, who collapsed upon hearing his sentence, was told by the judge, 'I regard yours as the worst case, or as bad as any. There were eight boys involved under twenty-one years of age.' There were ten charges against Holly in total, and he pleaded guilty to all of them.

The court heard that all those cases centred on Holly, and others incriminated had been introduced by Holly. Holly's defence said that he was perfectly convinced that at the time the accused was incapable of understanding the gravity of the offences, and that Holly had pleaded he had done no harm to anybody, except those who were addicted to similar practices.

What evidently influenced the judge in his sentences was the consideration as whether the accused were principals and whether they had corrupted youths. He extended leniency and good advice to those whom he thought had been led astray.

Rowe pleaded guilty to five cases of indecency. All cases concerned youths under twenty-one, and two of them were under eighteen. There were twenty-three other cases of gross indecency that did not involve the corruption of young boys. The court heard that Rowe was a man of exceptional talents, and it was tragic when such a man went wrong, and like Lucifer fell into the lowest depths. After sentencing Rowe to five years the judge said, 'The best that can be said about you is that you admitted all the offences.'

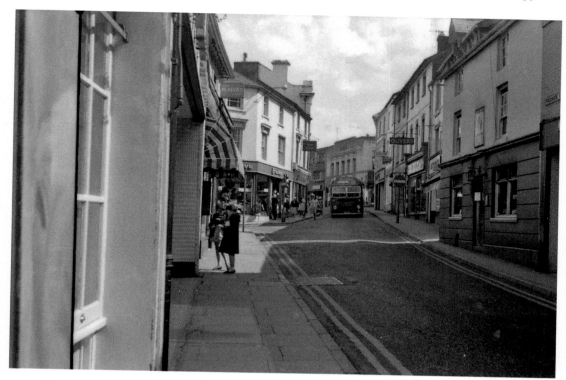

Above and below: The changing face of Abergavenny.

Above and below: The scandal rocked the sleepy town of Abergavenny and was soon brushed under the carpet.

Dr Burrows of Hereford, speaking as an expert in psychological medicine, said that homosexuality was due to arrested development and Rowe's defence asked his lordship to accept the medical evidence that this was one of the diseases of the mind, which acquired proper treatment. He also said that Rowe was as sorry about it as anyone in the court.

James Taylor who came to Abergavenny from London after the outbreak of war was sentenced to seven years after having twenty-six charges of gross indecency against his name. Taylor said that he had corrupted no-one in whom homosexual tendencies were not already existing.

Associate of both Holly and Taylor, Oswald Pugh, who was paralysed down the right side of his body owing to a certain disease, was told by the court he had abnormal sexual instincts. The court also declared that because he was so physically disadvantaged and likely to remain so, that in itself was considerable punishment, but nevertheless sentenced him to a total of six years.

One of the accused named Trevor George Jones, an accomplished female impersonator, pleaded guilty to twenty-four offences and was sentenced to five years. The court heard how Jones had gone to Cardiff and other places in the hope of meeting people with similar tendencies. His defence submitted that whatever the accused did it was with the full consent of the people involved. His defence also told the court that he would recommend the accused a change of environment and that he should do harder work on a farm under a master of fairly strong personality.

James Duffy, who hailed from Ireland and was a conscientious objector to the war effort, was sentenced to three years for offences spread over a number of years.

Alongside Holly, Frederick Percival Turner was the only other defendant sentenced to ten years. Turner, a married man, had attempted to commit suicide in Port Talbot by taking 133 aspirins. The judge said to Turner, 'Your case is in the same category as Holly, worse in some respects, considering the position you held.'

A thirty-eight-year-old bank clerk from Blaina who pleaded guilty to offences at the house of Rowe, stated that he was corrupted at public school. Mr R. Somerset said everyone knew that there was a certain amount of this sort of thing going on in public schools and always had been, 'A lot of people grow out of it, but sometimes in the unfortunate case of this man, they did not.' He added. The judge said he did not share this view, and that this case had not much to do with a public school.

In the case of a twenty-two-year-old hotel porter, the court heard how he had been described as more like a girl than a boy. He was described as distinctly more effeminate than any of the persons charged, and he did not appear to have any masculine tendencies. His mother said that her son had maintained her for two years and he had been a good boy to her. On imposing a sentence of fifteen months on the man, the judge told him, 'I want you to realise that this is being done for your own good, and I believe it will help you.'

To the four accused who were bound over in the sum of £10 for two years, the judge said, 'You are very young and not subject to tendencies of this kind. Do not be led astray again or it will go ill with you. I have evidence that satisfies me, that you realised that you were falling from the right path and tried to curb your evil ways some time ago. I bind you on the understanding that you will place yourself in proper hands if it becomes necessary.'

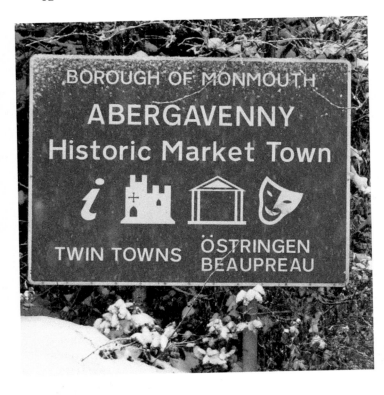

Left and below: 1942 put Abergavenny on the map for all the wrong reasons.

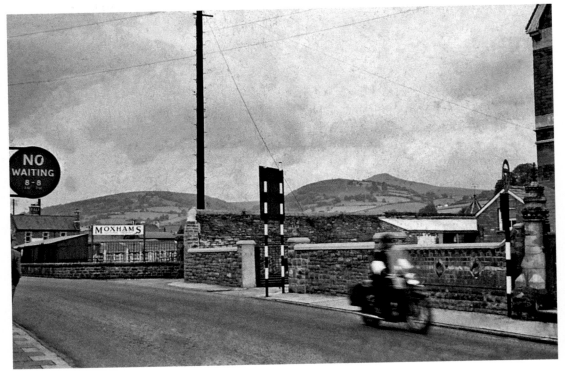

During the course of the hearing the judge asked, 'Are all these men from Abergavenny?' Mr Raglan Somerset replied, 'No my lord, some are from other places.' The judge added, 'If they were all from Abergavenny it strikes one that there must be a remarkable number of men there suffering from arrested mental development.' Mr Raglan Somerset finished by saying that Abergavenny has acquired an unfortunate name because of these offences, but it must be clear that Abergavenny was not entirely to blame. The discovery was made there, and the net was extended.

The crucified Christ situated just outside of Our Lady & St Michael's Catholic Church is a notable landmark in the town.

DID YOU KNOW?

Royal Mail is not always known for its speedy service, but a horse by that name, bred at Abergavenny's Tredillion Park, put in a first-class performance to win the 1937 Grand National.

DID YOU KNOW?

In 1958 Abergavenny's mayor, the energetic alderman William Horsington, made the bold claim that he was the only man in the borough who has put his hand on the weather vane at the top of the town hall spire.

'It happened about fifty years ago, but I am certain it has not been repeated,' said the mayor.

How did it happen? Steeplejacks were covering the town hall spire with copper and Mr Horsington went up with them: 'I wanted to make sure they made a good job of it', he said.

DID YOU KNOW?

When the National Eisteddfod was first held in Abergavenny in 1913, a group of Suffragettes seized the opportunity to burn down the town's cricket pavilion. Howzat?

7. The People That Time Forgot

Abergavenny has always enjoyed more than its fair share of character and colour, and through the centuries and down the decades it has produced many a colourful character. People, like places, often get lost in the murk and mist of time, but thankfully we've got a light and it burns really bright. So let's scatter the shadows and ride the lightning as we descend deeper and deeper into the abyss to meet the people time forgot.

The B-side to Marty Wilde's famous 'Taking a Trip up to Abergavenny' was called 'Alice in Blue.'

Abergavenny Alice

Let's begin our great tour into the unknown with the tale of a fiery young lady who put Abergavenny on the map for all the wrong reasons. Abergavenny Alice was a one-woman killing machine and poignantly proved beyond a doubt that hell really does have no fury like a woman scorned.

The story goes that sweet little Alice accompanied her Welsh Norman lord during the Fitzgerald-led Norman invasion of Ireland in 1170. Although apparently outnumbered upon their invasion of the Emerald Isle, the Normans knew a thing or two about overwhelming superior odds and employed their chess-like battle tactics to kill 500 Irishmen and take a further seventy of them prisoner. Alice's Marcher lord and lover also lost his life in the fray, and the Abergavenny damsel's distressing response was to pick up a mighty axe and personally behead all of the poor unfortunate wretches who had been taken captive.

Here's a strange old thing. The B-side to Marty Wilde's 1968 classic, 'Taking a Trip up to Abergavenny' was entitled 'Alice in Blue', although it's doubtful this was in homage to Abergavenny Alice's somewhat legendary hormonal mood swings.

Potato Creek Johnny

Down South Dakota way in the city of Deadwood you'll find the Mount Moriah Cemetery. This resting place is the final abode of many murderers, madams, mavericks, misfits and legends of the Wild West, such as Calamity Jane, Wild Bill Hickok and Seth Bullock. Nested in one corner of this notorious graveyard is a patch of America that'll be forever Abergavenny, because it house the mortal remains of Potato Creek Johnny, aka John Perrett.

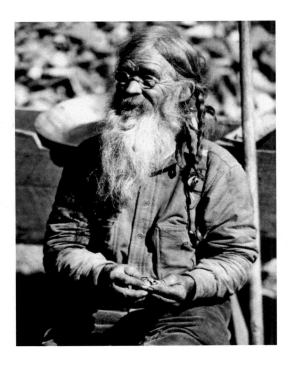

Potato Creek Johnny.

Above and below: It's not just people time forget, places change a lot as well. Look how different Llanfoist Bridge and Abergavenny Castle looked in the 1960s.

In life, Potato Creek Johnny was one of Deadwood's most flamboyant characters and was renowned for discovering one of the world's largest gold nuggets. Although he stood just over 4 feet in his boots, Johnny was a larger than life sort of guy and after leaving Abergavenny and making his was across the Atlantic to America when he was but a mere lad of seventeen, he headed straight to the hills of South Dakota in search of gold. For years Johnny trawled the streams of Potato Creek in vein, but like any good pioneer worth his weight in gold knows, all good things come to those who wait.

In 1929 perseverance and patience paid off for the prospector in a big way when he hit the ultimate payday and stumbled across one of the world's largest gold nuggets. The leg-shaped nugget weighed in at 7¾ troy ounces but almost immediately this massive lump of the good stuff attracted controversy.

Locals accused Johnny of stealing the nugget from a neighbouring miner and that it was actually a mass of gold created by melting three nuggets together. But Johnny remained unperturbed and unruffled by the claims, which were never proven, and sold the nugget to E. Adams for $250, which was a lot in those days.

The chunk of gold was put on display at Adams Museum in Deadwood and went on to become a tourist attraction, alongside its finder. Subsequent visitors to Deadwood would watch a long-haired and grizzly bearded Potato Creek Johnny pan for gold as the diminutive fella would regale the tourists with tales of prospecting and other legends of the Wild West. The impish prospector who travelled from over the pond in Wales and became a rooting, tooting genuine cowboy died aged seventy-seven, in February 1943.

Hillary Clinton

If not for Donald Trump, the next President of the United States of America could have been from Abergavenny stock. According to Hillary Clinton's family tree her paternal great-grandparents were Llangynidr man John Jones and Abergavenny woman Mary Griffiths.

If Hillary had trumped Trump and become the first female to rule the roost in the White House, she could've strengthened the already historical bond between Wales and Washington. Five of the first six Presidents of the USA were of Welsh descent, and the ten presidents to date with Welsh connections include John Adams, John Quincy Adams, Thomas Jefferson, James Morrison Jr, James Monroe, William Harrison, Abraham Lincoln, Benjamin Harrison, James A. Garfield and Calvin Coolidge.

Hilary wrote in her autobiography that her father got his looks from a 'long line of black-haired coalminers,' and that 'Wales has a special place in her heart.' Alongside thousands of other coalminers and their families, Hillary's great-grandparents John and Mary moved to Pennsylvania, where Hilary's grandmother Hannah Jones was born in 1883. Considering that her mother's family were from Pembrokeshire, Hilary has more than a little Welsh blood in her veins.

John Fielding

John Fielding was one of the 'legendary eleven' to receive a Victoria Cross for his valour at Rorke's Drift, and although he is more often associated with Cwmbran, John Fielding was actually born in Abergavenny's Merthyr Road on 24 May 1857.

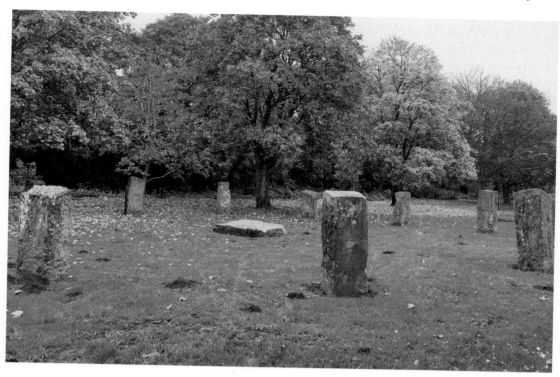

Above and right: Two more famous
Abergavenny landmarks. The Eisteddfod
Stone Circle in Swan Meadows and the former
King Henry VIII Grammar School, which is
now a Masonic Lodge.

Private John Fielding, who served as Private John Williams, was one of the 150 men who successfully defended the remote British outpost known as kwaJimu ('Jim's Land') against 4,000 angry Zulus. Aided and abetted by the trusty Martini-Henry rifle, albeit, 'with some guts behind it', Fielding was one of the courageous few who successfully repelled wave after wave of the most powerful and feared warrior nation that Africa had ever nurtured.

Fresh from slaughtering an entire British garrison at Isandlwana on the morning of that fateful day (22 January 1879), the 4,000 battle-hardened Zulu warriors then turned their attentions to the tiny British garrison situated on the banks of the Buffalo River in Natal, South Africa. Determined to rid their beloved homeland of the despised colonial Redcoats, the Zulus attacked with all the wild abandon of a patriot's zeal as the British boys, miles from the green grass of home, gritted their teeth, steadied both hand and aim, and put steel in their resolve as they faced down certain death.

After a battle that continued throughout the night and into the early hours of the following morning, the Zulu army, which had suffered heavy casualties, saw the British relief column approaching and finally withdrew. It eventually transpired that the British had lost only seventeen men in what became known as the battle of the 'Heroic Hundred', while the Zulus had lost 300. Both sides showed incredible valour.

A twenty-one-year-old Fielding was in the mission hospital when the Zulus attacked and, alongside fellow soldier Private Alfred Hook, held the hospital against all odds until his ammunition ran out. The two soldiers then fought hand to hand and eyeball to eyeball with the enemy to allow the hospital's patients to escape with their lives.

Fielding was the last of the eleven Rorke's Drift VC holders when he died in 1932.

DID YOU KNOW?

In Poet's Corner in Westminster Abbey there lies a memorial stone created by Abergavenny-born sculptor Harry Meadows, commemorating the poets of the First World War. It was unveiled by Ted Hughes on 11 November 1985, and among others bears the names of Wilfred Owen, Siegfried Sassoon and Robert Graves. None of the sixteen poets whose names are inscribed on the stone are actually buried in the abbey, and the inscription around the names reads, 'My subject is War, and the pity of War. The Poetry is in the pity.'

Ethel Lina White

It's something of a mystery as to why Ethel Lina White is so unknown today, because the Abergavenny-born crime writer was something of a household name in the 1920s and '30s on both sides of the pond. So much so that her celebrated novel *The Wheel Spins* was adapted by Alfred Hitchcock into his award-winning 1938 film *The Lady Vanishes*. A title that is quite apt considering what happened to our Ethel.

The Lady Vanishes.

Born in Abergavenny in 1876, the young writer left her office job working for the Ministry of Pensions and wrote a series of books, which gained her immense popularity, comparable to other greats of the genre such as Agatha Christie.

For her time, Ethel appeared to have quite radical views. Take this exchange between two characters from her book *The Third Eye*:

I feel that in these days of upstarts and profiteers, a long pedigree means everything. Do you not agree?

No ... that's all old stuff ... I place personal achievement far higher ... I can't see that any one has a right to feel elevated above the crowd just because he is standing on a pile of mouldy bones.

Sadly for Ethel, obscurity beckoned and she died in London in 1944 aged sixty-eight.

Vulcana

When fifteen-year-old Kate Williams met married family-man William Hedley Roberts in an Abergavenny gymnasium in 1890, the two fell in love, left town, and stayed together for the rest of their lives, most of which they toured as the brother and sister double act Vulcana and Atlas.

The daughter of an Abergavenny preacher, Vulcana earned worldwide fame for her strong woman act, and although Atlas was prone to exaggerate his lifting capacities, Vulcana was the real deal who set the world on fire with her freakish feats of strength.

Yet it wasn't just dumbbells that earned Vulcana her enviable reputation. At the age of thirteen she stopped a runaway horse in its tracks in Bristol, and once, to the delight of astonished onlookers, lifted and freed a wagon stuck in a lane in Maiden Lane, Convent Garden, London.

Closer to home, in 1901 Vulcana saved two children from drowning in the River Usk, and bizarrely in 1910, she was the first to inform police that her friend Cora Crippen had gone missing, which set in motion the chain of events that would lead to the investigation, prosecution and execution of Cora's husband, the notorious Hawley Harvey Crippen.

Vulcana and Atlas retired in 1932, and although they never married, they had six children together. Vulcana was pronounced dead after being knocked over by a car in London in 1939; she survived the ordeal, albeit partially brain damaged, but died seven years later in 1946, the same year as her husband and youngest daughter.

Vulcana.

In honour of the Abergavenny woman's exploits and achievements, the Vulcana Women's Circus in Brisbane, Australia, is named after the girl they used to call Kate.

DID YOU KNOW?

Abergavenny sprinter Fred Cooper may have been the first man in Britain to clock ten seconds for the 100-yard sprint, but the Monk Street-born pocket rocket failed in the one contest that mattered to him most – the 279-yard dash from Abergavenny's Town Hall to the Swan Hotel in the time it takes the town's clock to strike twelve midday chimes.

Many athletes have attempted to pick up the time-honoured gauntlet since, but it has defeated all who have bravely laced up their running shoes. If Usain Bolt fancies one last great challenge, Abergavenny awaits.

DID YOU KNOW?

Abergavenny's cricketing hero Graham Nash will always be remembered for being on the receiving end of a world-record-breaking six sixes in one over during Glamorgan's match with Nottinghamshire at Swansea in 1968. The man in bat was Sir Garfield Sobers. History was made again thirty-eight years later when the ball smashed around St Helen's by the West Indian legend was sold for a world record £26,400 at Christie's in London. The only trouble was it couldn't have been the right one because it was the wrong make, a Duke's Avenger and not a Stuart Surridge. The plot thickens.

Ben Hayle

To be hung once is unfortunate, to be hung twice is just unheard of, except if you're Abergavenny-man Ben Hayle. The story goes that at the turn of the nineteenth century Hayle was condemned to the hangman's noose after being found guilty of killing a gardener near the gates of St Mary's Church. Although a blood-stained knife was found at the scene, legend has it that it belonged to Hayle's friends, and it was they who stabbed the gardener.

What truth there is in this we'll never know, but what we do know is that Hayle was placed unceremoniously in a cart with a noose around his neck, the cart was driven away, and Hayle was left swinging in the breeze. After around an hour of being left high and dry, Hayle's body was cut down and handed over to his friends. Here's the wow part. Hayle apparently wasn't dead, and although a little worse for wear after being executed

by the state, he was happy to be alive and in the company of his mates, who hid him somewhere in Abergavenny.

Yet after being spotted in a window by a local lass who subsequently informed the authorities, Hayle was recaptured, put back in the noose, and hung again until he was dead, dead, dead, beyond all reasonable doubt.

Friends of Hayle's later erected a stone in St Mary's Church with a rope carved around it, but like so many things it has now disappeared into the abyss of yesteryear.

St Mary's Graveyard is now a garden of ease.

8. Taking a Trip up to Abergavenny

In 1968 the crooner Marty Wilde famously sang about taking a trip up to Abergavenny, where he passed the time with the 'Paradise People' who lived there and mentioned something or other about a 'red dog running free.' The song was of course called 'Taking a Trip up to Abergavenny' and this jaunty little piece of the psychedelic pop pie that was the swinging '60s often falls loosely from the lips and puts the shake in the hips of many Abergavenny natives after a few ales. But above all, this blast from the past poignantly sums up how Abergavenny is above all an enchanting place to visit.

For years the town's Tuesday market has attracted huge crowds from the valleys, who descend with unfailing regularity on every second day of the week and, to paraphrase Marty, 'hope that the weather is fine' so they can wander the streets and take in the sights. With each passing year, the town's Food Festival, Cycling Festival, Steam Rally, and a wealth of other events consolidates Abergavenny's position on the tourist map.

Jeremy Clarkson rides into town on the strangest choice of transport.

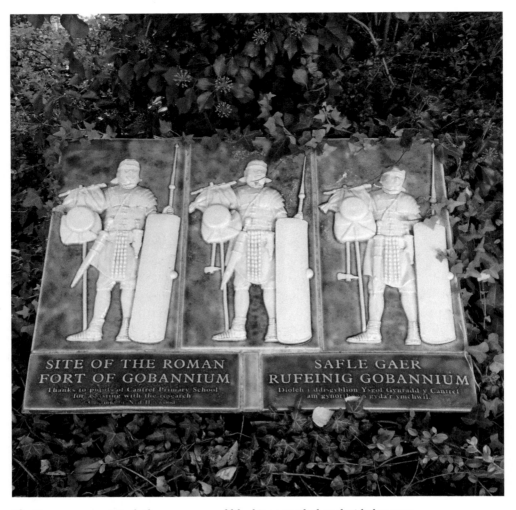

SITE OF THE ROMAN
FORT OF GOBANNIUM
Thanks to pupils of Cantref Primary School
for assisting with the research

SAFLE GAER
RUFEINIG GOBANNIUM
Diolch i ddisgyblion Ysgol Gynradd y Cantref
am gynorthwyo gyda'r ymchwil.

The Romans once visited Abergavenny and liked it so much they decided to stay.

Yet familiarity breeds, if not contempt, a lack of appreciation for what's on your own doorstep. The ticking of the clock changes everything, and even though the environment you inhabit day in and day out seems so familiar and permanent, it is in actuality in a state of perpetual change. It's a stark and unforgiving fact that one day you wake up, blink your eyes and everything has changed beyond all recognition, and the worse thing is you never appreciated it when it was there. That's why a visitor's perspective can often unearth hidden facets of the town you live in, but were completely oblivious to.

Take the story of Barrie Sylvester for example. For this fresh-faced newcomer to the area during the war years, the Blorenge, Sugarloaf, Deri, and Skirrid mountains that surround Abergavenny were not only reminders of nature's breathtaking beauty, but they also conjured up happy memories of how protected and safe he felt here as a child during the Second World War.

Above and below: A curious blend of the old and new is still visible in most parts of Abergavenny.

Alongside thousands of other children across Britain who were evacuated to rural areas during the war, Barrie spent a large part of his formative years in a place far removed from his home town of Folkestone, which in 1939 was notoriously nicknamed 'Bomb Alley' as a consequence of the German's habit of emptying their planes of any leftover bombs that remained from their raids over London on Folkestone, before heading the 22 miles back across the channel.

Among many others forced to flee hearth and home and seek sanctuary in the relative safety of rural Britain, Barrie found shelter in Abergavenny from the terrible storm raging through Europe. 'It took me ages to pronounce Abergavenny properly,' said Barrie, who arrived here from Folkestone in 1941 at the age of five, 'I used to call it Agerbergenny.'

Barrie explained,

The reason my mother finally decided it was time for us to leave Folkestone came about after me and my brother Brian were playing in the street one day, and a fighter plane flew overhead. Now because we were both so young we didn't realise the difference between a German and Britain plane, so we both stood and waved, and the pilot waved back. The plane then circled back on us and came flying over the street all guns blazing, but the strange thing is we weren't afraid, because at that age you are still not really aware of fear or your own mortality.

However, the event was enough for Barrie's mother to decide that a move was the safest option, and before long Barrie and his brother found themselves living in Llanfoist with Mr and Mrs Barber, while Mrs Sylvester moved to Abergavenny's Victoria Street and found herself a job in a munitions factory.

During his time in Llanfoist, Barrie, alongside twelve other evacuees, attended school in what he describes as a 'green hut', but in actuality was the village hall. 'Looking back those were very happy days in Llanfoist,' said Barrie, 'I remember once an American army truck pulled up in the village and distributed sweets or rather American "candy" to us, which was a very kind gesture and much appreciated. Another stand-out memory was seeing Indian soldiers on horseback riding through the village, and I still wonder why would Indian soldiers be riding their horses in South Wales?'

Although to this day when Barrie reminisces about Llanfoist, it is the canal that conjures up the most evocative memories: 'Brian and I used to walk through the cemetery, and climb another hill until we came to the canal. Words cannot describe the view, so picturesque. My memories of the canal on a quiet summer's day will stay with me forever. The atmosphere of underlying calm and embracing serenity will always be remembered by me with undying affection.'

Because Mrs Sylvester quite naturally didn't want her boys separated from her, their spell in Llanfoist came to an end when their mother secured them a place in Victoria Street School. Barrie said, 'After changing schools, mum was offered a place for us by Mr and Mrs Williams who lived in Westgate Buildings at the bottom of Tudor Street, right opposite Laundry Place.' The boys were only taken in on the condition enforced by Mrs Williams that they attended the Salvation Army. 'I really do have a lot to thank the

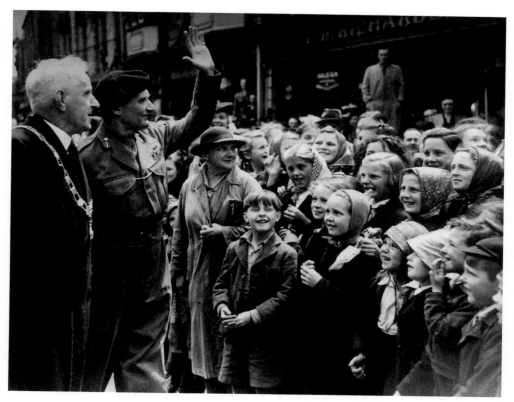

Not long after the Second World War, Field Marshal Montgomery paid Abergavenny a visit.

Salvation Army for,' said Barrie, 'I had a wonderful time at band practice, and played, or rather, attempted to play the tenor horn. We were also treated to Sunday school outings to Barry Island, and Porthcawl, and I picked up a lot of valuable skills and disciplines from the Salvation Army that have stood me in good stead throughout my life.' Barrie also added,

> Mrs Williams was truly a wonderful lady, and really cared for us. She had three children of her own to look after, and all of us were well fed, always had clean clothes, and of course we had our weekly bath in the tub near the fire. The only disadvantage was the cleaning of the ears. A matchstick would be placed inside a face cloth and wriggled about. I didn't like that one bit, but I still have nothing but praise for Mr and Mrs Williams and her family.

During Barrie's time in the Williams' household, a poignant occasion occurred for the Sylvester's when Mr Sylvester arrived in Abergavenny on leave. 'To be honest I hardly recognised him,' recalls Barrie, 'He was already a regular solider before the war started, but what a wonderful surprise. Brian and I had a photo taken with him at the back of Westgate Buildings, and we also had a family photograph taken with mum. These are

Prince Charles is a frequent visitor to the town. On his last visit the prince can be seen here meeting 'the King,' or the 'Abergavenny Elvis', as the man in the blue suit is more frequently known.

treasured keepsakes, especially because I assume that photographic film was not exactly in abundance in those days.'

Another favoured treat for Barrie and his brother while living in Abergavenny was the Saturday morning children's cinema at the Coliseum. Barrie reminisces, 'After visiting the cinema we would cross over the road to Nevill Street, then down to Victoria Street to visit mum, and then we would continue to Murphy's Shop on the corner of Pant Lane for a penny bun, and then back home to Westgate Buildings. They were truly halcyon days.'

After the war, at the age of ten, Barrie, Brian, and his mother left Abergavenny and were reunited with Mr Sylvester. Barrie ultimately went on to have an illustrious musical career in the Royal Marines, where he travelled the world and played at such historical events as Sir Winston Churchill's funeral, the 1966 cup final between England and Germany, the marriage of Prince Rainier to Grace Kelly, the Queen's Silver Jubilee, and countless other royal engagements. Barrie said, 'I would like to thank the Abergavenny Salvation Army for my basic musical training, because without it my life may have taken another course completely.'

Despite always keeping a piece of Abergavenny forever in his heart, Barrie was unable to return here until 2005, fifty-nine years after he first departed. Barrie said, 'When I came back in 2005 and I walked through 'the cutting' to Llanfoist and climbed back onto

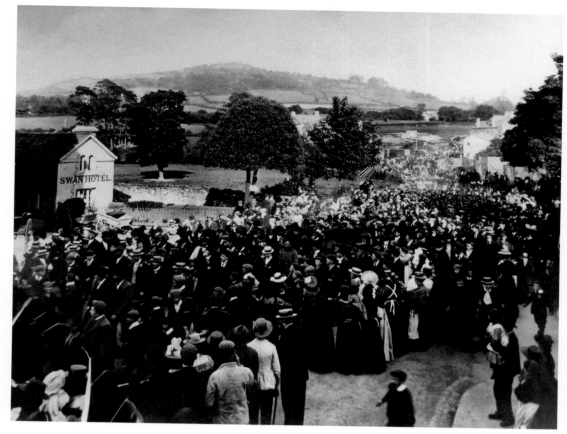

When troops returned from the Boer War, a lot of curious visitors marched alongside them.

the canal I could have cried, and when I visited the Mayor's parlour and was presented with a tie with the town's crest upon it, I was so proud. It's difficult to describe how fond I am of Abergavenny, but I like to think of myself as an adopted citizen of this lovely, lovely town.'

Perhaps Barrie's feelings about the local area can best be summed up by a strange and captivating story he told me during our conversation about his time here. Barrie revealed,

This is going to sound bizarre, but I swear it is true. One day me and my brother were on the canal and enjoying the view, when I looked to my left and saw this lady in what I would now describe as her early to mid-thirties with long red hair. She then said, 'This is Heaven', and I thought that she was so right. I turned to my brother and told him what this lady had said, and he said 'What lady?' I looked to my left and she had disappeared completely, and although there was a long stretch of towpath stretching into the distance, she was nowhere to be seen. I have never forgotten that moment, and to this day I think that if the Abergavenny area is really Heaven, then God couldn't have picked a better home.

Almost seventy years after finding sanctuary and falling in love with a sleepy little South Wales market town he had never heard of, Barrie appeared on ITV in a new, five-part documentary series called *Evacuees Reunited* that covered the stories of fifteen evacuees from across Britain and was hosted by Michael Aspel.

DID YOU KNOW?

On the official opening of the Abergavenny Library its benefactor Andrew Carnegie addressed the gathered assembly thus, 'The land of knowledge and literature are more valuable than all the dross and gold piled together. I need not defend libraries they defend themselves. Wherever I found them, I found the fountains from which healing water always flows.'

The Hollywood Stars, British Royalty, and Buffalo Bill

Among the famous visitors to Abergavenny in the 1950s was American film actor Gregory Peck, when he stayed in the town on his way to Fishguard to star in the film *Moby Dick*. When Hollywood royalty Richard Burton and Elizabeth Taylor stopped in Abergavenny

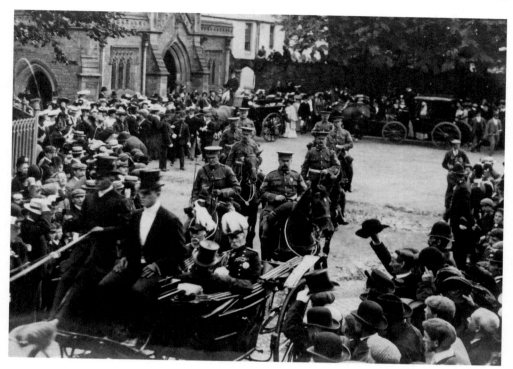

Earl Roberts visits the town after successfully leading British forces to success in the Boer War.

en route to Merthyr on 4 September 1963 for a bite of something to eat and something wet to wash it down with at the Angel Hotel, celebrity diets and strict regimes didn't exist. The hard-living power couple enjoyed a steak and kidney pie and a bottle of claret – a bit different from tofu and camomile tea. Elizabeth II and Prince Charles have been regular visitors to the area, and Queen Victoria did pass through the town once on her way to Haverfordwest, but she was only a girl at the time. She stayed for a short time in front of the Angel Hotel while the horses were changed.

George IV also passed through Abergavenny, and a number of local people were hoping that they would be able to pull his coach for a few hundred yards, but the king announced that he would not allow his subjects to take the place of horses.

One of the most flamboyant characters to ever grace the town was the Wild West's William Cody, also known as Buffalo Bill. The rooting, tooting, cowboy, who is said to have killed 4,282 American bison, brought his Wild West spectacular to the leafy environs of Bailey Park on 3 July 1903 as part of his European tour. There was space for 14,000 spectators at Bailey Park and the two-hour show, which was held beneath electric light, included an Indian attack on a wagon.

The German Connection

A German man who first visited Abergavenny in 1952 became so enraptured with the Gateway to Wales that he has religiously returned to the town every year since. As a

Udo Schultz.

nine-year-old German lad, Udo Schhultz had never visited Britain, let alone Wales, before; it was a strange but fascinating experience for Udo, who explained,

> I first came to Abergavenny with my mother Wilma to visit my Uncle and Aunt, Elton and Anne Williams. Aunt Anne met my uncle not long after the war when he was sent to Kiel with the British Army to help repair the city's dock. My aunt was working as a translator in Kiel when she met her future husband. They fell in love and returned to my uncle's hometown of Abergavenny to be married, and that is the simple twist of fate which led me to this lovely town.

During his first trip to Abergavenny Udo recalled how he fell in love with the surrounding countryside and revealed, 'Up until that point, my world had been Kiel, which is by the sea and very, very flat. Here you have mountains, and such beautiful mountains. I remember picnics on the Blorenge and Sugar Loaf, and playing cricket in the meadows, and thinking what a wonderful place to live. It seemed such a small and friendly community and the people were so pleasant. When we left, I remember I couldn't wait to return.'

And return Udo did. As a boy, as a man, as a husband, and as a father with two daughters of his own, whom he named Megan and Arwen in tribute to his family's long-standing

Thomas Carnegie visits the town and decides to build a library.

Welsh connection. During his fiftieth visit Udo was given a special reception by the town's mayor and is proud to call himself an adopted son of Abergavenny.

Thanks to his passion for photography, (much of which is featured in this book) Udo has chronicled extensively over the years the changing nature of Abergavenny, and said,

> Because you are protected by your beautiful mountains, the climate, compared with some of the surrounding areas, always seems to be sunny and mild. I like to think Abergavenny brings the sun out for you and out in you. In my life I have travelled a lot and seen a lot of the world, and let me tell you, places like Abergavenny with its rich history and character are unique. That is why I come back here for three weeks every year, and look forward to every visit.

The Forgotten Lady

Out of all the visitors to Abergavenny, it's probably the unnamed woman who died here in the 1890s that remains the most mysterious. The story goes that a well-dressed lady, who carried an air of immense wealth, took suddenly ill in a stagecoach that was forced to stop in Monk Street, where a kind woman allowed her the use of a bed and called for a doctor.

Yet it was to no avail. The next day the mysterious lady died without saying who she was or where she came from, leaving nothing but a purse containing a large sum of money and no clue to her identity. Extensive enquiries were made as to who the lady

was, where she was from, and where she was going, but there was less than zero in way of forthcoming answers to solve this elusive enigma.

The mysterious lady was buried in St Mary's Churchyard with the following inscribed upon her tombstone: 'She, for I know not her name.'

DID YOU KNOW?

The Bishop of Hereford visited St Mary's Priory Church in Abergavenny in the early 1300s for the unusual reason that the monks' behaviour was so bad that the bishop had to visit and sort things out.

A Tramp's Tale

And finally, wearing a tattered suit and an unmistakable look of determination, Mr Francis Kendall-Husbands passed through Abergavenny in the 1950s on his merry way to Fishguard. The red-bearded self-styled 'King of Tramps' stopped at a pub to quench his thirst in time-honoured fashion, before telling a *Chronicle* reporter, 'Wales is still the most kindly disposed country to us tramps.' The happy wanderer then went on his way, but not before announcing his attention to set off for the Vatican to seek an audience with the Pope.

Hordes still descend upon Abergavenny's ever-popular market.

Clarkson rides out of town in style.

DID YOU KNOW?

The famous gentleman of the road and lover of alcohol W. H. Davies once wrote, 'O what a merry world I see, before me through a quart of ale.' Apparently he was inspired to pen the lines in Abergavenny's Hen & Chickens pub.

9. Running Out Of Steam

Abergavenny was once known as a railway town and many of its inhabitants were railway men. During its glory days, the great locomotive depot in Brecon Road and the town's three busy stations defined the geography of the town. All that remains now, however, are a few scattered remnants, buildings, and place names to help the inquisitive soul venture forth on the tracks of time and into a bygone era when the 'iron horse' was king and the hills were alive with the sound of steam.

Abergavenny still boasts a station that has survived the ravages of modernisation, and still carries a quaint, old-fashioned atmosphere about it that one can imagine having a 'Brief Encounter' upon. Yet despite all the rosy-eyed nostalgia that abounds in the modern world for the golden age of civilised travel and the aesthetic of the carriage, to many born into the era of the horse and cart, the locomotive was an infernal thing of great ugliness.

Mural in Abergavenny depicting how Abergavenny once looked as a railway town.

Take this letter printed in an *Abergavenny Chronicle* of 1908 for example:

Dear Sir,

Last Monday evening a few minutes to seven, we were walking to Llanfoist by the Castle Meadows. The hidden moon broke through a bank of cloud, and we turned to look at her, magnificent in her fullness, and in brilliancy dwarfing Jupiter, for to our ignorant eyes this planet appeared her close companion.

What was that before us? The creation of a moment; a lunar rainbow. The perfect bow stretched like an enchanted bridge of moonlight vapour. Behind it as a curtain of indigo dye, rose the Blorenge, its summit lost in heavy clouds - 'a mountain over a mountain.'

Darkness clothed the valley of the Usk, but the whitewashed houses of Llanfoist Bridge reflected the light of the moon, and each window and chimney could be distinguished.

In silence we gazed at that never-to-be forgotten scene - a scene no pen could have painted or a French impressionist rendered.

Gradually it faded. The last of that rainbow ghost was carried away on the smoke of a passing train, one of the many things that mar the beauty of beautiful Abergavenny.

Of course, fast-forward forty years or so and every kid in Britain wanted to work on the trains, as the now often ridiculed, but then hugely popular art of trainspotting clearly testified. Take this *Chronicle* report from 1952 if you will:

They poke their heads through station barrier rails, they perch on the parapets of railway bridges, they line the embankments; lie in wait at tunnels; stand patiently at level crossings; and gaze in wonder at the major junctions.

They are the trainspotters – that happy band of schoolboys who collect train numbers in much the same way as their mates collect stamps, matchboxes, and marbles. Abergavenny has quite a few of them.

As a hobby it has long gone unrecognised, but no longer, for now the train-spotters have their own mark of identity. It is a necktie which depicts a class of locomotive much loved by spotters.

The manufacturers of the tie have shown excellent psychology. Train-spotters may, with impunity, use their ties as pen-knife polishers or as hand de-greasers. For they are fully washable – yes indeed.

On the balmy evening of 8 June 2016 Abergavenny again became a nation of trainspotters, as hundreds, some estimates suggest thousands, of men, women, children gathered at various vantage points in the area to watch the legendary *Flying Scotsman* steam through the Gateway to Wales on its epic journey to the big smoke and Paddington Station.

The build-up had been immense, and anticipation was as hot as the sun that blazed fiercely in a sky free of clouds – almost as if the big ball of fire remained as determined as the rest of Abergavenny that nothing would obscure its view of the nation's favourite locomotive, back on track and roaring down the line like a rooting, tooting icon from a bygone age.

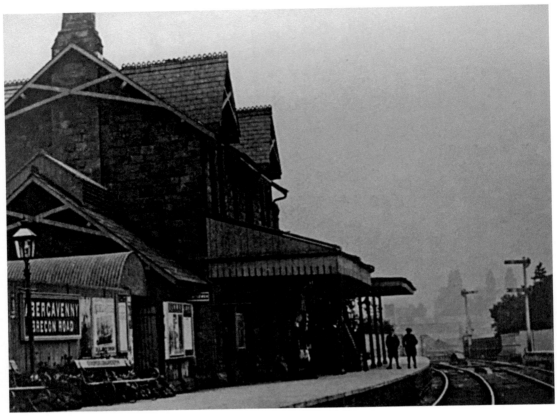

Above and below: The Old Brecon Road Train Station and a view of Llanfoist Bridge.

Above and below: One of the last great steam engines passes through Abergavenny on a tour of the provinces.

Abergavenny train station.

Nothing quite quickens the blood and enflames the passions of this rare breed of men who refer to themselves as 'train enthusiasts' and never the more derogatory 'trainspotter', than the romance and nostalgia inherent in the form and force of a vintage steam train.

Whether you're a train enthusiast or not, few people can remain unmoved by the sight of these rolling monuments to another era pulling liveried coaches across open country. The sublime splendour, rolling thunder, and the haunting cry of an old steam engine speaks to the 'inner anorak' in us all.

As a former Abergavenny steam engine driver once said, 'Until you have hurtled down the tracks in the early hours of the morning going hell for leather in a "Great Western" you haven't lived.' Or as Johnny Cash once sang in the Orange Blossom Special, 'Look a-yonder comin' comin' down that railroad track.' From the cities to the country, from the mountains to the sea of this fair country, people were appearing mob-handed to catch a glimpse of the *Flying Scotsman* following its £4.2-million refurbishment

In Abergavenny the crowds gathered at the old train station in hushed expectation to bear witness to the triumphant return of the *Flying Scotsman* as a working museum exhibit, conquering yet another record as the oldest mainline working locomotive on Britain's tracks. Leaving the works for the first time on 24 February 1923, and retired in 1963 by British Rail, the *Scotsman* has the rare vintage of being the first locomotive in the UK to have reached 100 mph in 1934. Many hoped it would adopt far more gentle speeds as it rolled through leafy Monmouthshire and its thriving population of wild bunny rabbits.

Above and below: What's that hurtling down the tracks?

DID YOU KNOW?

According to local hearsay, Abergavenny's Frogmore Street got its distinctive name because the street originally passed through a marshy area that was inhabited by a large number of frogs.

DID YOU KNOW?

In 1983 it was revealed by county councillor Jon Vaughan Jones that important civil defence equipment, to be used in the event of a nuclear war, was being held in the basement of Abergavenny Town Hall, but according to chairman of the emergency planning sub-committee Reg Morgan, the room was in a dreadful condition and was often used by vagrants as a urinal. Nevertheless rumours that there exists a nuclear shelter beneath the town hall persist to this day.

DID YOU KNOW?

Holywell Road is named after the Holy Well, which, many moons ago, was the water supply of the Benedictine Priory and was claimed to have healing properties. When local builder Mr Foster set about constructing the nearby Fosterville Crescent, he put the holy water to a more utilitarian purpose by constructing a horse trough, which is still visible to this day.

Earlier that day there had been confusion about the exact time the *Scotsman* would pass through. Its exact timetable had been fiercely guarded for fear its presence would attract the 'wrong types', whose enthusiasm for the great 'iron horse' would spill over onto the tracks, endangering life and limb and forcing the Scotsman to suffer the woeful indignity of a grinding halt. Oh the calamity!

Yet there can be no carefully protected secret or private moment that social media won't seek to make public and spread like wildfire with an added splash of extra petroleum. Thus, courtesy of Facebook, everyone and their dog knew by that afternoon the *Flying Scotsman* would pass through Abergavenny Station at 5.27 p.m.

Tick followed tock, and tock followed tick, and as the minute hand neared the appointed time of the great arrival, there was a muted murmur among the gathered assembled that the *Scotsman* had been delayed and would be at least half-an-hour late. Unthinkable!

There she blows! The *Scotsman* in all its splendour with the even more majestic Skirrid Mountain in the background.

Surely if any train should be on time it would be the *Flying Scotsman*. Was Britain's membership of the EU to blame for such a poor showing and decline in standards? Or had yet more train enthusiasts trespassed upon the track in a collective and instinctive urge to be as close as possible to the great icon of steam and civilization? None of it mattered. What did was that the *Scotsman* was still coming, it was just a matter of when.

Without a bilingual tannoy system to ease our troubled minds and calm our fevered souls with an exact time and reason for delay, the suspense was suffocating as we stood like a flock of anxious sheep without reason or rhyme, past or future, on a train station that hadn't been engulfed by steam for years.

And then, 'There she blows!' screamed someone, somewhere, but just not at Abergavenny, where the only sound in the strained silence was the lonesome buzz of a contemplative dung fly and the melancholy roar of a Peugeot 205 GTI on the old Monmouth road.

Yet all good things come to those who wait, and an almost imperceptible shudder of genteel excitement passed through the crowd as an elusive and slight noise indicated that something big and old was coming down the tracks. Without fanfare, without so much as a toot, without a rhythm section going chug-a-chug-chug, and without an apocalypse of smoke pouring forth into the sky and obscuring all reality but that of the great steam engine, the *Flying Scotsman* passed us by. Pushed by a diesel engine called the 'County of Essex.' Oh the indignity!

Like an old timer forced reluctantly out of a pleasant retirement, the *Scotsman* wasn't rolling down the tracks under its own steam alone. It was being paraded around the

country by a lowly diesel. If you blinked you would have missed it. And as the Great British icon was unceremoniously shoved up the track like an aging Hollywood starlet on a tour of the provinces, one disappointed little lad summed up the feelings of many in the crowd when he was heard to say, 'Is that it!' Indeed it was kid, indeed it was.

A diesel you say?

Don't worry there'll be another one along in a minute.